PAUL T. GRANLUND
SPIRIT *of* BRONZE • SHAPE *of* FREEDOM

By William K. Freiert

published by
Primarius Limited Publishing
Minneapolis, Minnesota

All sculptures in this book may be assumed to have been cast in bronze
using the lost wax process unless noted. Titles, dates, dimensions,
and locations have been verified with the sculptor and
are based on his records and recollection.
Single dimensions denote height.

Catalogue items are listed by year beginning with 1950.
Catalogue information includes title, date, dimensions, medium
(if other than bronze), and present location of public sculpture.
It may be assumed that sculptures listed without location
are in private collections.

Copyright 1991
Granlund Sculpture, Inc.
St. Peter, Minnesota 56082

ISBN 0-943535-04-2

Produced in the United States of America by
Primarius Limited Publishing
Minneapolis, Minnesota 55402

CONTENTS

ACKNOWLEDGMENTS 6

MYTHOPOET: THE MEDIATOR 9

SHAMAN: THE BOUNDARY-CROSSER 21

COSMOLOGIST: THE UNIFIER 33

UNMEDIATED SPIRIT 45

FOOTNOTES 60

BIOGRAPHY 63

CASTING BRONZE 65

CATALOGUE 69

INDEX 126

ACKNOWLEDGMENTS

Eudora Welty's literary agent, Diarmuid Russell, characterized himself as her "benevolent parasite," a term I am happy to expropriate in reference to my writing about Paul Granlund. I spent so many hours in conversation with Granlund and stole so many of his ideas that my first instinct was to call this book *Granlund on Granlund*. My first debt is to the sculptor for his great generosity in helping me to understand his work. At the same time I cannot pretend that my interpretation of any one piece or of his work in general is an accurate representation of the artist's intention.

Secondly, this book could never have been completed without the energies of Kelvin Miller and his staff at Primarius Ltd. Miller and Mavis A. Voigt edited the text and Primarius employees compiled the catalogue, assembled the photographs, did the layout, and handled all other details of the book's production. Those who had a hand in the task include Paul Batz, Denise Hite Bunch, Carol Hoseth, Joanne Johnson, Karen Lundquist, Liz Sietsema, and Caroline Vaaler. I am grateful to each of them and especially to Kelvin Miller for advice and assistance in writing the manuscript and for handling the book's technical details.

Credit must go as well to Granlund's staff, Tim Dougherty, Dave Hyduke, and especially Bev Gustafson, who, in addition to handling other duties, is responsible for catalogues and records. She was always generous, prompt, and efficient.

I am grateful to Public Affairs Director Elaine Brostrom and to Vice-President for Church Relations Dennis Johnson of Gustavus Adolphus College, as well as to the editors of *Classical and Modern Literature*, Professors James O. Loyd and Virginia Leon de Vivero, for inviting me to present parts of the material in this book, as it was developing, to public audiences.

I interviewed many people in preparation for this writing. Some of them have commissioned Granlund works, others own them or have been particularly interested in Granlund's career. The following were especially generous with their time and their insights:

Honorable Elmer L. Andersen, former Governor of the State of Minnesota
Wally Arntzen, Executive Director of H.E.A.R.T., Inc.
Richard Askey, Professor of Mathematics at the University of Wisconsin at Madison
Phyllis Berney of the National Council on the Arts
Edgar M. Carlson, President Emeritus of Gustavus Adolphus College
Russell Fridley, former Director of the Minnesota Historical Society
Phyllis Gerth of the Bethesda Lutheran Home
Robert E. Gibbons, President Emeritus of Viterbo College, La Crosse, Wisconsin
George Hagle, Professor of Art at the University of Wisconsin at Eau Claire
Owen Halleen, President Emeritus of Sioux Falls College, Sioux Falls, South Dakota
Rev. Richard L. Hillstrom, Curator at Lutheran Brotherhood
David E. Johnson
Nick Legeros
Neal Luebke

Sister Romana Miller, O.S.F.

Rev. Donald M. Meisel, Pastor of Westminster Presbyterian Church, Minneapolis

Thomas O'Sullivan, Curator of Art at the Minnesota Historical Society

Lois Rand (Mrs. Sidney A.)

Christine Roe of Lutheran Church of the Good Shepherd, Minneapolis

Rev. Robert P. Roth, Professor of Theology at Luther Northwestern Theolgoical
 Seminary

Larry Schnack, Chancellor of the University of Wisconsin at Eau Claire

Wilko B. Schoenbohm, Executive Vice President of Courage Foundation, Courage
 Center, Golden Valley, Minnesota

Edward A. Sovik

Richard Zehring

Work by the following photographers is included in this book:

Frank Agar	Jack Jennings	Paul Quist
Gerald Bushey	Tom Link	Jack Rendulich
Jane Champlin	Gary Mortenson	Stan Waldhauser
Allan Forrest	Loren Paulson	Steven Waldhauser
Liza Fourré	Robert Paulson	Beau Wold
Jennifer Grinnell	Dale R. Peterson	Joe Zimbroldt
Carol T. Hartwell		

I am grateful to Gustavus Adolphus College and to its Faculty Development Fund for material support for expenses incurred in doing research for this book.

Paul Granlund has said, "My wife Edna is half my sanity." Knowing Edna, one sees what he means. Her impact on Paul's life and his work is incalculable. Edna's hospitality to me and her refreshingly caustic humor have genuinely enhanced the pleasure I had in working on this project.

Kathryn Christenson has been an inspiration to me through her own writing about Granlund. For this, and for her personal efforts on my behalf on other projects, I will forever be in her debt.

Patricia Neaderhouser Freiert, Professor of Classics at Gustavus Adolphus College, was the first to read and edit the text of this book. Over the years she has taught me more than all of my other teachers combined, including a few things I did not want to know. I know of no better teacher. Of the many undeserved blessings in my life, the one I value most is the fact that I am married to my best friend.

To these Three Graces, then, Edna, Kathryn, Patricia, this modest work is fondly dedicated

ET DIS MANIBUS PARENTIUM CARISSIMORUM.

September 1991

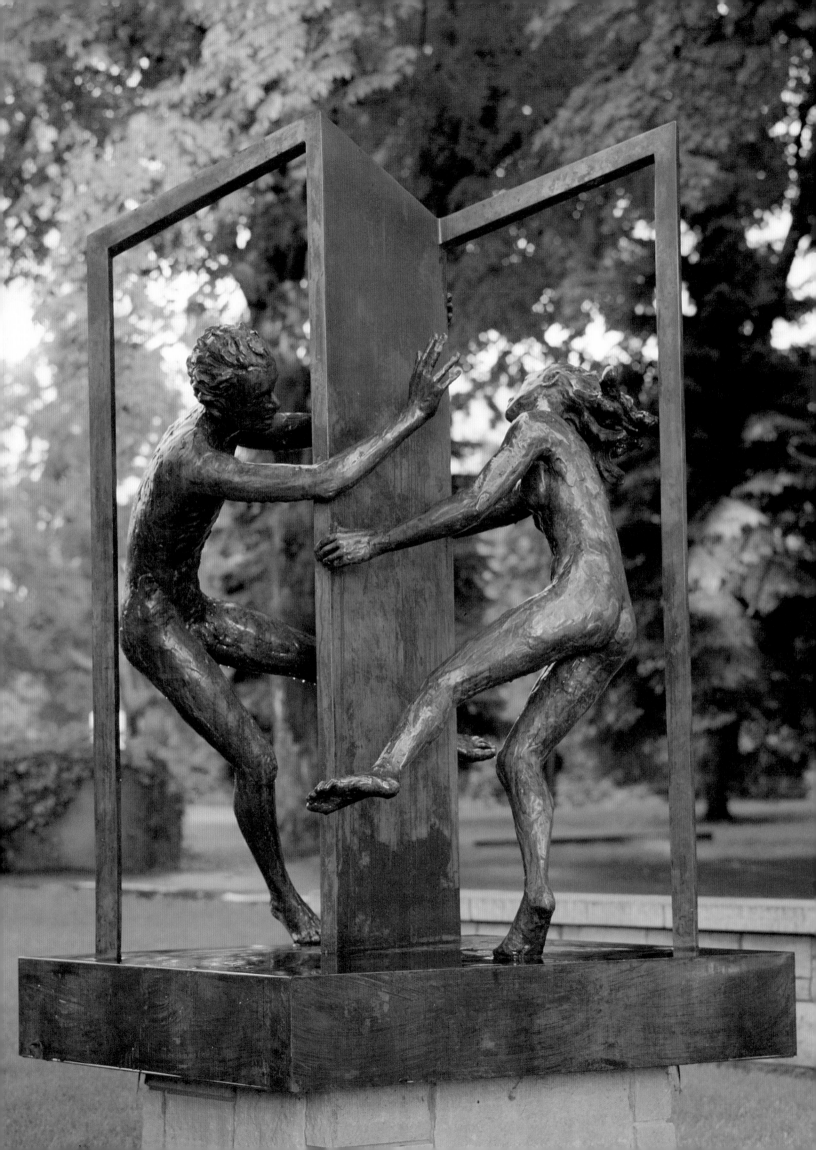

MYTHOPOET: THE MEDIATOR

Paul Granlund is a poet. His medium is bronze, but he articulates in molten metal the questions all poets wonder about: he refracts the myths that provide meaning for the human mind, he sings the stories that explore life's essence.

Granlund's sculpture is mythopoetic, not just because a number of his works deal with explicitly mythological themes such as Leda or Europa. More importantly, Granlund's sculpture achieves what the structuralists maintain to be the function of myth, which is to mediate contradictions. Myths enable us to comprehend the inherent tension between female and male, between grief and joy, between birth and death. Paul Granlund's bronzes mediate such contradictions.

The most pervasive motive in Granlund's work is that of bipolar tension. In *Adolescence* (1984), for example, a boy and a girl gleefully chase one another around a doorway. The flying arms and legs betray the combined thrill and terror of adolescent relationships, the eagerness of desire and the apprehension of vulnerability, the bittersweet longing for the opposite one cannot understand. Each teenager is balanced on only one foot, a sign of the precarious nature of an adolescent's emotional life. And each gropes with one hand around the door that separates them, reaching for the other that each wants but fears to touch.

Even more complex is the polar tension of *Adult Lessons* (1984). The title of this piece puns on that of *Adolescence*. But the flirting games that the young play have here yielded to the lessons adults must constantly work at, lessons of love, lessons of making one from two. While the adolescents are groping for one another, the adults are pulling at one another, still learning to give and to take. These adults are learning the lesson of mutuality, of polarity, of the creativity of opposition that is love.

Teeter Trio (1990) is a grouping whose carefree whimsy masks a profound example of creative polarization. Joyfully dancing the hora, male and female adults link hands

◄ *Adolescence*, 1984
6 feet

Myths enable us to comprehend the inherent tension between female and male, between grief and joy, between birth and death.

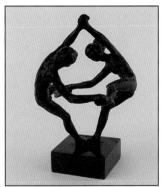

Adult Lessons, 1984
8 inches

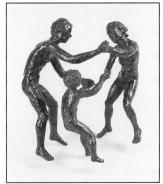

Teeter Trio, 1990
10 inches

with a child. Walking around *Adolescence*, one can feel the sculpture revolve. But *Teeter Trio* is a sculpture that actually dances, because it has three possible positions: female with feet on the ground and male with feet up in the air, female and male each with one foot on the ground and one in the air, and female in the air and male with both feet planted—thus the title: this sculpture teeters back and forth between male and female. The figure in the air actually seems to be jumping and if you suddenly catch the sculpture out of the corner of your eye you are sure that you saw it move. There are five theoretically possible positions in this arrangement, for the child could also be jumping and that is what you expect it to do, especially since so many Granlund pieces have parents tossing children. But in *Teeter Trio* the child is the point of mediation between the parents and is the focus of stability. The child is the fruit of the leaping of the parents and in the child lies the future of the parents. The creative tension between female and male, each teetering between earth and air, is stabilized and unified in the person of the dancing child.

The polarities in Granlund's work are present both in *imagery* and in *form*. Two contradictory images that run through many pieces are those of *egg* and of *bird*. And two symbiotic shapes are the inwardly curving *fetal* shape and its opposite, the exploding shape of the figure with *arched back*. Granlund most graphically exploits the imagery of the egg in a witty, yet profound sculpture titled just that. *Egg* (1979) cracks open to reveal two human beings floating in a complementary tension. The human is not one being hatched from one egg, but two mutually exclusive but mutually dependent creatures swimming in the creative fluids of whatever came first. Is this the Orphic world egg of ancient mystery religions, from which were hatched winged Love and all that exists?

Egg, 1979
5 inches

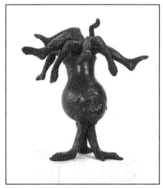

Medusa, 1965
15 inches

The egg shape appears in a much more overtly mythological sculpture, *Medusa* (1965), whose ovoid head has become a boiling cauldron of tangled human limbs, the snakey locks which appear to writhe in an effort to break out of their egg-shell prison and fly away. Medusa was a beautiful woman who had been turned into a Gorgon with snakes for hair and a face that turned anyone who saw it to stone. Freudians allegorize Medusa genitally, but Granlund's interpretation is not explicitly sexual. The tangled surging of the serpent-limbs is in stark contrast to the stolid, even lovely, face of Medusa. The tension between Medusa's beautiful face and her grotesquely writhing hair embodies every human's potential for both creativity and destruction, both love and malevolence.

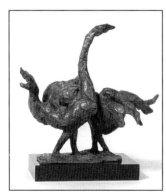

Leda and the Swan, 1962
10 1/4 inches

The lovers that hatch from Granlund's eggs must in the course of nature take to flight and the image of the bird as a metaphor for human love appears often in his work. That the lover flies is a commonplace of Freudian imagery. That the lover is the winged divine sky is a commonplace of archetypal mythical imagery. And so Granlund's *Leda and the Swan* (1962) is one product of his musing about what he

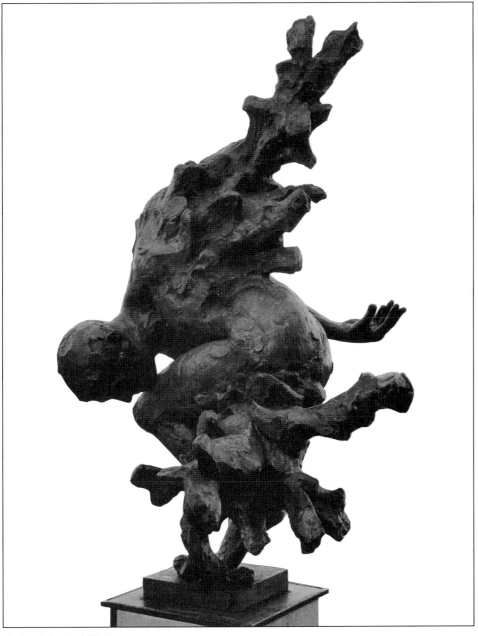

*The lovers that hatch from
Granlund's eggs must in
the course of nature take to
flight and the image of the
bird as a metaphor for
human love appears often
in his work.*

Jacob and the Angel III, 1962
63 inches

terms "the question of the intrusion of the gods into the affairs of men." Zeus came
to Leda in the guise of a swan. In Granlund's retelling, as Leda reclines her head on
the swan's back and is protected by his wing, she appears to sprout wings for legs.
Furthermore, the arms on which Leda balances herself aloft are plainly suggestive of
the legs of a bird. Leda, too, is beginning to fly. In fact, it is she who is borne aloft
while her winged divine love stands squarely on the ground. As she perches beneath
the swan's phallic neck, Leda strikes a tense posture which combines an arched back
with the drawn-up knees of the fetus. In another *Leda and the Swan* (1972), Granlund
has Leda again perching on her arms in a way that suggests a bird's legs. In fact, a side
view presents Leda's arms as the actual legs of the swan. The two have literally
become one.

Jacob's nocturnal struggle with the Angel (see *Jacob and the Angel II* [1961]) is perhaps
the story that preoccupied Granlund most in his wrestling with the intrusions of the

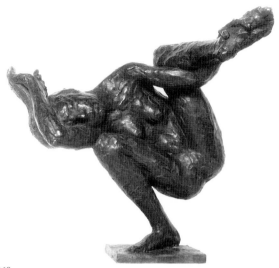

Ambivalence III, 1960
16 1/2 inches

gods into the lives of humans. Jacob wrestles with the winged angel of the Lord, which is, in reality, Jacob himself. This piece is tense with ambivalence. And the introspection of the brooding Jacob is wrenched apart by the motion of the soaring angel. In *Jacob and the Angel III* (1962), the tension is heightened still more. One is torn between the expectation that the tortured creature will plunge down to earth in fetal brooding or that it will soar up into the sky on its lovely angel-man wings. We know, though, that Jacob emerges from this nocturnal struggle with the angel of his soul, as a free man with a newly created identity, that of Israel, "he who strives with God" (*Genesis* 32:28).

Bethesda Angel (1968) is another scripturally inspired sculpture that reminds one of a bird. It is based on the noncanonical verse 4 of John 5, in which the movement of the healing water of the Pool of Bethesda is attributed to the descent of an angel. The angel's flowing robe begins in the pool at his wrist and gushes upward to become wings as if the robe-wings consist in reality of water.

Bethesda Angel, 1968
66 inches

Sleeping Phoenix (1961) combines the image of the *bird* with the shape of the *fetus*. As its wings begin to stir, the figure perches on a hand. Its opposite-side human limbs touch earth and its winged limbs start to fly. This chthonic-etherial polarity appears again in four pieces, each called *Ambivalence* (1958, 1959, 1960, 1967). All of these pieces portray a human figure perched like a bird, with one upper limb and one lower limb intertwined. Their title, *Ambivalence*, plays on the word's technical meaning, as used in psychology and in chemistry, the ability to interact or unite in either of two directions. These fetal creatures confuse upper with lower limbs and are torn both ways at once.

Sleeping Phoenix, 1961
10 inches

A more subtle ambivalence exists in *Lotus Eater* (1961), whose drug-induced fetal shape is a return to the womb as an escape from the rigors of life's journey. Her assumption of the life-promising shape is rife with mythic ambivalence. And Granlund heightens the polarity with the contrast between the figure's curved lines and its straight lines. Its fetal curve is contrasted with the crossing horizontal and vertical lines of the limbs. The Lotus Eater perches bird-like on its toes, and at the other end of that vertical line the creature's hand reaches up tentatively, like the bud of a flower, offering the same promise of life that the curve of the breast does in the center of the sculpture.[1]

All cultures' stories begin with Creation mythology. The birth of myth is the birth of ideas, the birth of mind, the birth of self-consciousness.

Lotus Eater, 1961
13 1/2 inches

The tension inherent in life-giving is vividly portrayed in *Birth of Myth* (1963) and *Suigeneris* (1963). *Birth of Myth* is a fusion of two beings in inverted union which is simultaneously productive of itself as a winged creature with human arms and legs, egg-shaped and flying, begetting and being born. The spiritual quality suggested by wings is reinforced here by the notion of creativity implicit in the concept of myth. All cultures' stories begin with Creation mythology. The birth of myth is the birth of ideas, the birth of mind, the birth of self-consciousness. Speaking of the not unrelated sculpture, *Poet and the Muse* (1963), Granlund has said, "Man as maker becomes part of the creative process." Theatre director Neal Luebke's definition of "to be entertained" is "to be held from within." To take the other within oneself and hold him there, to be held inside the other until new life surges is the physical analogue of the creativity of the mythopoet, whose contact with life is both sensual and spiritual, emotional and conceptual, tactile and verbal. Each of the two figures in *Birth of Myth* is giving birth to the other in the same mythic ambivalence that is the origin of all life and thought.

Half Tryst and the Other Half (1985) illustrates well the interrelationship between the fetal shape and its opposite, the exploding arched back shape that permeates so much of Granlund's work. *Half Tryst* came first. It is archetypal Granlund, a nubile female figure caught in a dance posture, with one foot planted firmly and the other nearly off the ground, with torso arched backward until the head is starting to point downward

Birth of Myth, 1963
6 1/2 inches

Together these flying lovers constitute the eternal form of the egg with which all began.

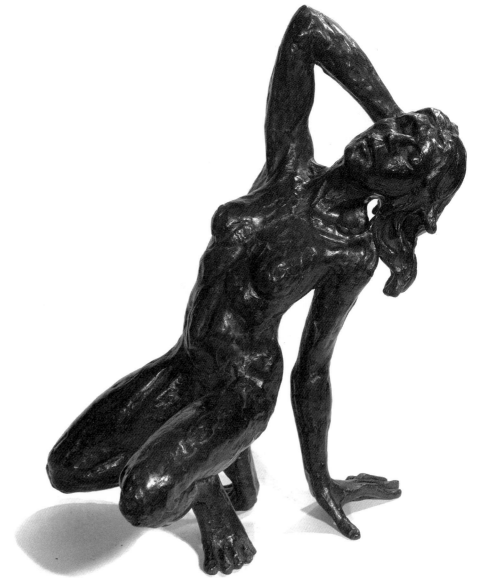

Morning, 1977
17 1/4 inches

and the smooth neck is stretched taut, with arms flying in curves that echo the line of the torso in a smaller and higher arc. *Half Tryst* is a typically sensuous piece that, like so many Granlunds, calls out "touch me." From the feet which Granlund does so well, the ankle that "feels" exactly like an ankle, through the saucily protruding stomach, to the hands cupped as if to catch the rain, the dancer is alive with the joy of youth. She is engaging in a "half twist" and her title is one of those puns that delight Granlund and exasperate his friends. Asked by his wife, Edna, where the other half was, Granlund created *the Other Half*, a complement in several ways to *Half Tryst*. *The Other Half* is male, his twist is the imploding fetal curve, and he does not touch the ground at all. *The Other Half* is a separate sculpture and, while one of his employees likes to arrange the lovers in a variety of different "positions," Granlund intended for *the Other Half* to hang by his right hand from either hand of *Half Tryst*. So these two young lovers represent together both the imploding fetal shape and its opposite exploding shape. But these two forms comprise a whole and each one is only "half." Together these flying lovers constitute the eternal form of the egg with which all began.

All birth is explosive as a mother rips open in violent spasms of pain and the tightly compressed fetus suddenly wails and flails its limbs at the shock of the cold, unpredictable medium in which it must now swim. *Dance* (1978) is a sculpture which illustrates the transition from fetus to birth explosion. The lowest of the

Dance, 1978
12 inches

interconnected human figures is curled up on the floor with arms positioned to begin rising. The second dancer, with arms opposite one another like a swimmer's, is still curled up but rising on one knee. The third is emerging from the fetal curve but has left the ground and floats horizontally. And the fourth is flying with feet uppermost and back arched sinuously in the posture that is the exact opposite of the fetal first dancer. *Morning* (1977) and *Mourning* (1977), taken together, show the same polarity. The languid stretching of the early rising *Morning* becomes the tortured agony of the grieving *Mourning*, the pain of whose fetal posture is heightened by the backward twisting of her arms, like those of a racked prisoner. Together *Morning* and *Mourning* represent the pleasure in life of the arched back and the pain of loss that causes one to curl up in retreat.

The pain of death is expressed in its extremest form in the *Ophelia* sculptures. In both of these pieces, the arched back is that of the dead Ophelia, although in *Ophelia II* (1965) the butterfly suggested by the pinioned limbs hints at the life possibility inherent in death.[2] But the arched back implies life in Granlund's work as often as it does death. *Bacio* (1963) and *Lovers* (1969) are two works in which the figures' arched backs reinforce the carefree joy of their kisses.

Half Tryst and the Other Half, 1985
12 inches

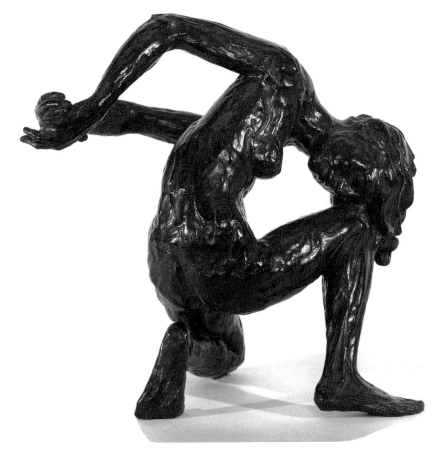

Mourning, 1977
13 3/4 inches

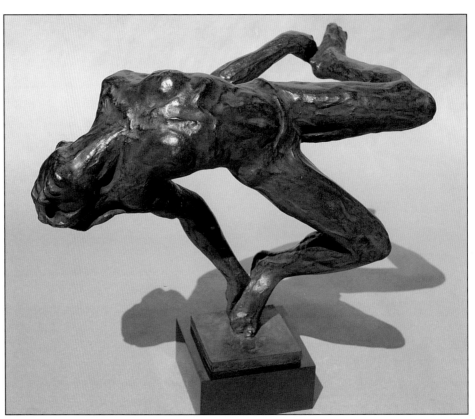

Ophelia II, 1965
14 inches

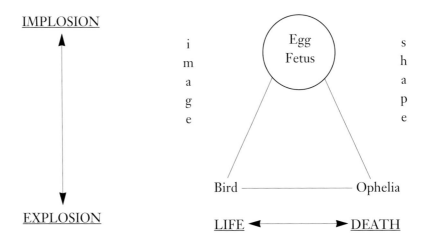

The image of *egg* and the image of *bird*, the form of *fetus* and the *arched-back* form of sculptures like *Ophelia* share a kind of symbiotic proportional relationship. Structuralists might say that the egg is to the bird as the fetus is to Ophelia. In a sense the flight of the bird in Granlund's sculpture and the arched-back posture of the Ophelia type are both positive and express what Granlund terms "explosion."

Contrasted to "explosion" is the "implosion" of the self-contained egg and the inward turning fetus. On the level of explosion, the bird image affirms life, while the Ophelia shape tends to connote death. On the side of imagery, the bird implies life and explosion, while the egg implies life and implosion. On the side of form or shape, Ophelia frequently asserts death and explosion, and the fetal posture as often asserts death and implosion, as in the *Lotus Eater*. But as a matter of fact, the egg motif and the fetal shape are one and the same, and we have even seen several pieces in which the fetal shape bore a distinct promise of the hope of coming life. Thus egg-fetus mediates the contradiction between life and death as manifested in the flying bird and the floating Ophelia. Just as the egg and the fetus are the same, so life and death are one, as in *Jacob and the Angel*. Furthermore, it is foolish to assign singular meanings to any Granlund image or form, as if he were a medieval allegorist.

Orbit (1983) combines the ovoid shape of a sphere with the arched-back posture. Male and female fly mutually in orbit around one another, linked in the gentlest of polarities. These twin stars hold one another's feet, left hands touching right feet and

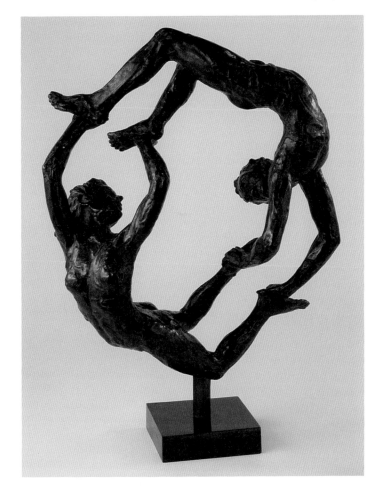

Orbit, 1983
31 1/2 inches

A rainbow is light refracted through space, but for Granlund the rainbow is a movement refracted through time, the movement from male to female, the growing relationship of lovers, the mediation of opposites.

Toe to Toe, 1988
10 3/4 inches

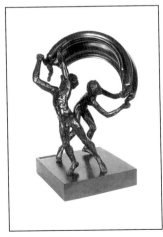

Rainbow, 1980
8 3/4 inches

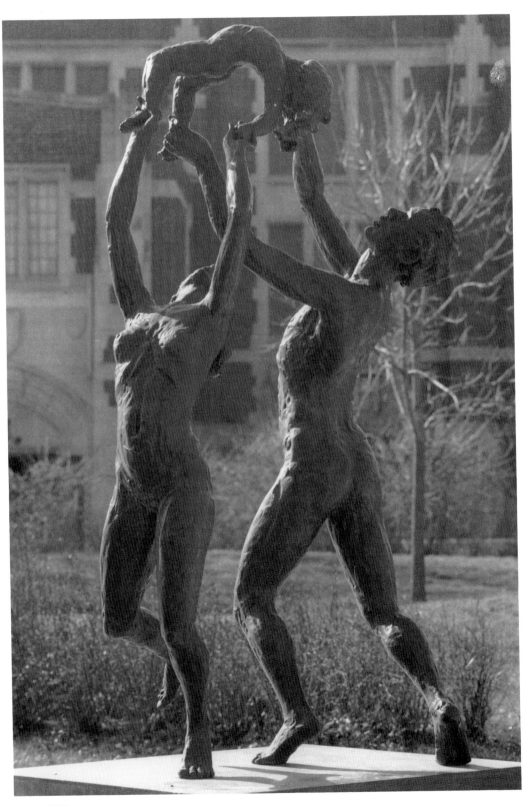

Apogee, 1980
6 feet 2 inches

vice versa. The twist of the arched bodies as the lovers look back over their shoulders at one another creates a pattern of two interlocking circles.

Similar mutuality can be seen in *Toe to Toe* (1988). Male and female stand with the big toes of their left feet touching. That they touch the inner toe of the mate already suggests intimate gesture. That intimacy increases as each lover's right leg is elevated vulnerably and rests on the extended left arm of the beloved. Joining opposite limbs of wrestling lovers (nurturing arms with marching legs) heightens the tension between giving and taking, pleasing and being pleased. Finally, each right arm cradles the beloved's head as they move toward a kiss. They are one from head to toe. What is the point of this "mediation"? What kind of myth is this poet singing? The mediation of opposites becomes palpable in *Rainbow* (1980) in which lovers throw the rays of the rainbow back and forth between one another's creative hands. A rainbow is light refracted through space, but for Granlund the rainbow is a movement refracted through time, the movement from male to female, the growing relationship of lovers, the mediation of opposites. *Rainbow* is related to a series that similarly unites creativity with geometry. The gestures of the lovers in *Rainbow* reappear in *Apogee* (1980), as the rainbow that mediates the lover's upreaching joy is their child, whose arched back gleefully forms the north pole of their sphere, the apogee of the orbit in which they spin.

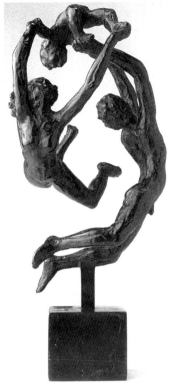

Zerogee Model II, 1983
8 1/2 inches

Granlund says, "*Apogee* is a sculpture about a family at play."[3] *Perigee* (1979) is the complementary piece to *Apogee*. And Granlund completes the series with *Zerogee Model II* (1983), a pun on the title of the first two and an allusion to zero-gravity, for in *Zerogee* the lovers are no longer earthbound. As they float freely in space, the female is completely aloft, structurally supported only by her link with the child. This floating in freedom gives us a taste of the inner significance of Granlund's mediation of opposites. It is, in Granlund's words, "the process of being freed," which underlies the structure of imagery and shape in the polarities he sculpts: the process of being freed to explode in the ambivalence of life-creating death.

In 1981, H.E.A.R.T., Inc., a private foundation dedicated to helping people in rehabilitation from substance abuse, commissioned Granlund to create a piece which would express that organization's mission. The result was *Free* (1981), in which the human spirit surges upward to freedom from male through female, who is floating but supported by her lover, to child who flies aloft elevated and caressed by both parents.

The process of being freed is one that never ends. The very essence of "process" is continual change. The freedom of the flying woman in *Zerogee* can be seen equally well in *ad infinitum* (see next page), a chain of freely floating figures, each smaller than the last, receding forever into space, outer space (and thus the perspective of distance in the smaller figures) or inner space (towards the microcosm of the infinitely small). It is a process that goes on generation after generation.

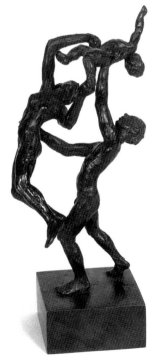

Free, 1981
10 3/4 inches

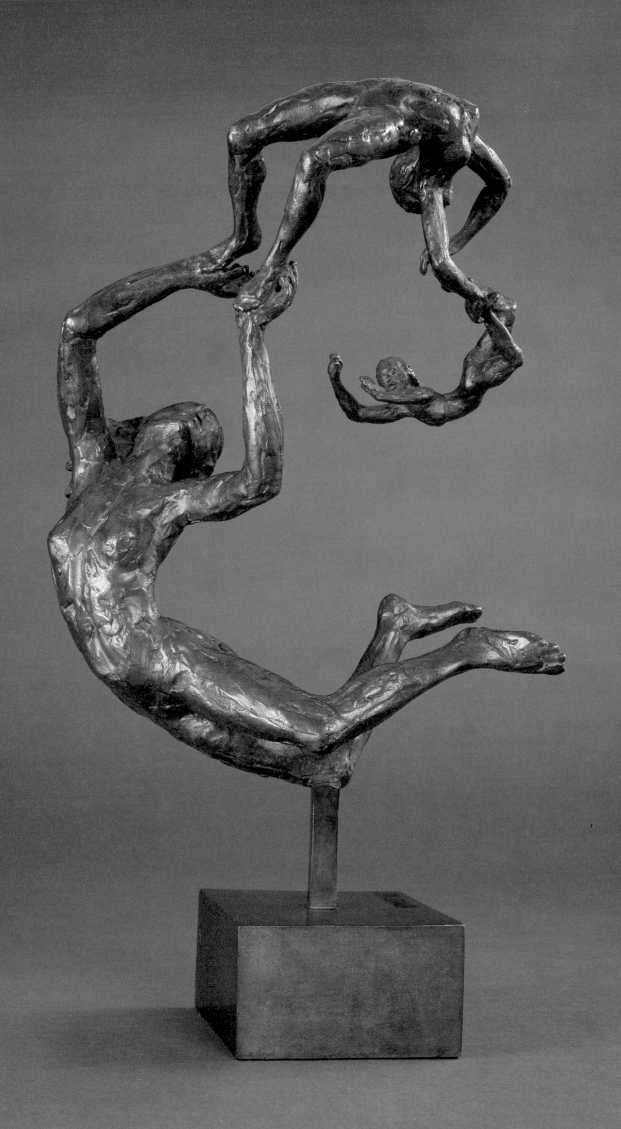

SHAMAN: THE BOUNDARY-CROSSER

2

Paul Granlund is a shaman. His medium is bronze, but his spirit reaches back across the boundaries of generations to fire living traditions and to pour them into new shapes for the generations to come.

A shaman is a priest in a small-scale society who dreams significant dreams and converses with those in the other place. It is his duty to cross the ultimate barrier and return with good news for his people, the news of a meat-providing hunt, a fertile harvest, or a shocking truth.

The ultimate boundary is that between generations. It is an infinite divide that separates life-givers from those who receive life, those on the way to death from those on the way to growth. In *ad infinitum* (1979), human figures grasp the ankles of their children, who continue on forever in unbroken succession, and they also grasp the ankles of those from whom they have come—the ever-receding images of ancestors decreasing in size as they approach the horizon of vision. Yet each member of the sequence is distinct and can meet the other only at the boundary of the touch. Like so many Granlund sculptures, *ad infinitum* calls us to touch an ankle and join the dance of ages.

The spiral of *ad infinitum* recalls that of *Continuum* (1975), the monumental representation of the helix of DNA that was commissioned for the bicentennial of Dubuque, Iowa. In *Continuum*, history, humanity, and geometry merge in a commemoration of two hundred years of cities linked by rivers, of human beings linked by their genetic code.

The shaman stands midway between his parents and his children, between his teachers of spirituality and his disciples, between his civilization's heritage and its future. Paul Granlund did not seek to be a shaman. His father was the shaman, or as close to it as one gets in reformed Christianity. He was a very prominent Lutheran pastor, noted for the strength of his convictions, who feared that Paul would go to

The ultimate boundary is that between generations. It is an infinite divide that separates life-givers from those who receive life, those on the way to death from those on the way to growth.

Continuum, 1975
14 x 24 feet, stainless steel

◀ *ad infinitum*, 1979
15 inches

Families touch in ways that affirm their union but also signal the precarious nature of all linkage and the fragility of relationships at the boundaries.

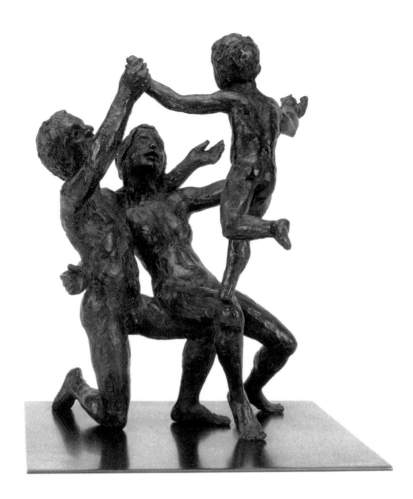

Pride and Joy, 1989
11 1/4 inches

Father and Son, 1950
30 inches, lead relief

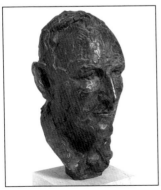

Head of My Father, 1967
14 1/2 inches

college, study philosophy, and lose his religion. Granlund was willing to oblige his father's pessimistic prediction. When he returned to civilian life after the second World War he realized with a shock that he was alive and that he was not *just* his father's son. Number One in the catalogue of Granlund sculptures is a lost piece titled *Father and Son* (1950). Although Granlund was not thinking of his relationship with his own father at the time, the theme of the sculpture is that of the prodigal son, who is being wrapped in a cloak by his welcoming parent. Granlund would return to this theme in 1963 and in 1968, each time portraying a jubilant father catching a flying child in his arms.

Touches between parents and children grace so many Granlund sculptures, from the families (*Family*, *Rondo*, and *Family Circle*) of the middle seventies, through the *gees* (*Apo-*, *Peri-*, and *Zero-*) of 1979-80 and 1983, to the recent *Pride and Joy* (1989). Families touch in ways that affirm their union but also signal the precarious nature of all linkage and the fragility of relationships at the boundaries. "Play seems risky," Granlund observes, adding that family members support one another at times of risk. He notes that the space between the members of the family in *Pride and Joy* is a sphere (nature's perfect container), but "It's almost as if the child is on the other side of the world" from its parents. The time difference between parents and child is related to the space difference, for time and space are functions one of the other. The time boundary that separates parent from child is penetrated and obliterated when parents help children break through the space boundary of the family circle, journey to new spheres of their own, and create new boundaries of new generations.

At the end of the second book of Vergil's *Aeneid*, Aeneas describes his desperate flight from burning Troy. At his side was his young son Ascanius, the hope of the future, from whom would descend the Roman race. On Aeneas' shoulders was his aged father Anchises, the representative of dying Troy. And in Anchises' arms were the household gods, the images of ancestors from ages innumerable, the entire past of the house of Aeneas. All of us carry our ancestors in the arms of our genetic code just as we transmit that code to the continuum of our descendents.

A famous ancient Roman statue depicts a man holding the busts of his ancestors, and important progenitors' busts adorned the homes of Roman families, for whom tradition was a sacred value. Granlund crosses the generational boundary with portrait busts of his parents, too. Granlund's *Head of My Father* (1967) depicts the indomitable spirit of a man who was convinced he knew God's will, softened by the compassion of a caring parent. Granlund projects poetry in all his portraits, putting himself into the mind of his subject, thinking what he imagines to have been their thoughts, feeling their emotions. The whole notion of a portrait bust is based on the Roman virtue of *pietas*, loyalty to the traditions of one's family, one's community, and one's religion. Seeing and transmitting the poetry in the soul of one's physical, national, and spiritual forebears is something that is characteristic of all Granlund's portraits. That of *Bernt Julius Muus* (1984), the founder of St. Olaf College, for example, projects the furrowed brow and concerned look that must have been more typical of a nineteenth-century founder of a church college than the stern prophetic glare one usually sees in the faces of others photographed during that period.

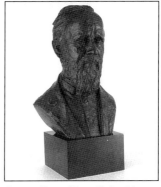

Portrait/Bust of Bernt Julius Muus,
1984
25 inches

Perhaps Granlund's most difficult bust was that of the great Indian mathematician *Srinivasa Ramanujan* (1983), the only available photograph of whom was a faded passport photo. Nevertheless when Richard Askey, who was responsible for commissioning the Ramanujan bust, saw the clay model in Granlund's studio, he was moved to say that it *was* Ramanujan. "He had captured the view I have of Ramanujan as a very intelligent man with great interests in life." And Ramanujan's widow commented, "It was as if his spirit had returned to our home."

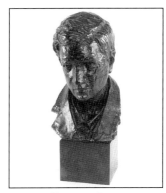

Portrait of Srinivasa Ramanujan,
1983
22 1/2 inches

Granlund's *pietas* goes in both directions. He is concerned with crossing the boundaries to future generations even more than to those in the past. His busts of his own children and grandchildren reveal the spirit of each child and hint at the adults they have and will become. The *Head of Gregory* (1958), one of Granlund's sons, was cast in Aeneas' (and Michelangelo's) Rome, while Granlund's grandchildren were modeled in his studio at Gustavus Adolphus College.

Mothers play as important a role as fathers in Granlund's work. His third sculpture was a black-walnut *Kneeling Madonna* (1950), reminiscent of Henry Moore, and his first experiment with imploded space was *Mother and Child (Madonna)* created in 1951. In *The Mothers* (1978), two mothers who lived at different times in the same historic

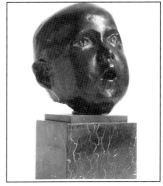

Head of Gregory, 1958
7 inches

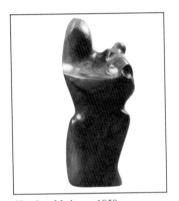

Kneeling Madonna, 1950
14 inches, wood

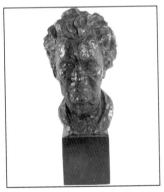

Head of My Mother, 1986
21 inches

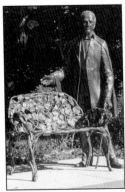

Henry Shaw, 1990
6 feet 3 inches

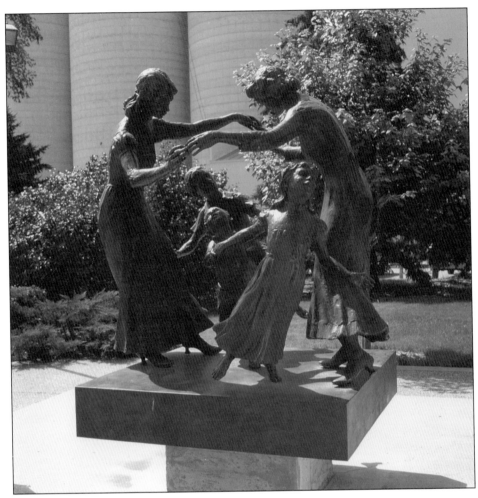

The Mothers, 1978
64 3/4 inches

house play London Bridge with their children, forming a spherical space. The mothers are separated from one another by a generation and they touch only at their fingertips. The children, representative of children of different generations, dance in succession through the tunnel formed by their swaying mothers. In 1986 Granlund sculpted the portrait bust *Head of My Mother* and one of his favorite answers to those who ask him where he gets his ideas is, "My mother helps me," a witticism revealing the profound principle that the sculptor is the medium for all the lore absorbed at mother's knee from time immemorial.

Another sculpture that harks back to earlier generations is a work created for the Missouri Botanical Garden in St. Louis. *Henry Shaw* (1990) is depicted in a life-size bronze, standing behind a bench whose filigree structure suggests the intricate vegetation of the sculpture's public setting. To ensure verisimilitude Granlund did extensive research on Shaw and on the period, studying pictures of Shaw and consulting historical society archives. But when he began modeling the sculpture, a waistcoat of his wife's grandfather served his purpose best.

Perhaps the life-size portrait for which Granlund is best known is his *Charles A. Lindbergh–The Boy and the Man* (1985), that stands at the Minnesota State Capitol in St. Paul, as well as in Paris, France, and San Diego, California. In the Lindbergh sculpture, Granlund breaks through the boundary between adult and child by portraying the aviator in both guises. As a child himself, Granlund had loved the idea of flying and littered the basement with stylized model airplanes. He enlisted in the Army Air Corps during World War II, hoping to become a pilot. Inspired by Lindbergh's description of his childhood fantasies involving sprouting wings and flying across the Mississippi, Granlund portrayed the future hero as a boy with arms outstretched, soaring in his imagination into the future. Behind him strides Lindbergh the man with the confidence and vision of the accomplished flyer—one

To those who ask where he gets his ideas Granlund frequently replies, "My mother helps me," indicating the profound principle that the sculptor is the medium for all the lore absorbed at mother's knee from time immemorial.

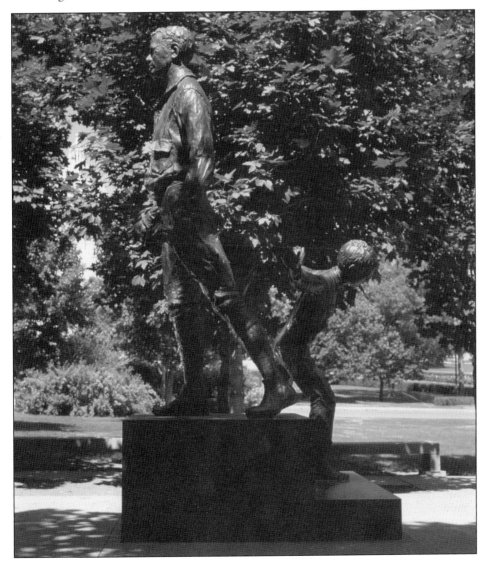

Charles A. Lindbergh–The Boy and The Man, 1985
9 feet 8 inches

Charles A. Lindbergh–The Boy and The Man, detail

Each generation is revolutionary, each is the transmitter of the past, seen through present eyes.

man in two generations, striding in opposite directions, the adult the offspring of the child's dreams. Although the boy and the man do not touch, that boundary between living and dead was breached momentarily at the unveiling of the statue. In a poignant scene, Anne Morrow Lindbergh, the flyer's lifelong companion, reached up and held the hand of her husband. As she paused with head bowed, many bystanders were moved to tears.

The succession of life continued to occupy Granlund as he created *Life Tree* (1986). The sculpture asserts the chain of continued life that, for Christians, grows from the wood of the cross. A cross flowering with the body of Christ is surrounded by seasonal figures flying toward new life. Each is a branch of the family tree that grows forever, from a mother and child to a figure curled up in burial, like a fetus preparing for rebirth.

Life Tree is a variation on the *New Testament Door* (1962) of Christ Chapel at Gustavus Adolphus College, in St. Peter, Minnesota. Christ Chapel is Granlund's St. Peter's, for it bears his work on each of its outer and inner doors. These doors, more than any other sculpture, represent Granlund's crossing the boundary to his spiritual heritage and bringing that heritage back to the community of the future. Harold Bloom talks about the inevitability of the influence of one poet upon another. "Poetic Influence—when it involves two strong, authentic poets—always proceeds by a misreading of the prior poet, an act of creative correction that is actually and necessarily a misinterpretation."[1] And Granlund speaks of an artist's mission to seek new realities, "by doing some violence to the orders that existed before."[2] Each generation is revolutionary, each is the transmitter of the past, seen through present eyes.

While Granlund worked on Christ Chapel, his father had retired from his pastorate and was able to spend long hours discussing the project with his prodigal son. In the course of these conversations the senior Granlund came to realize just how profoundly the truths to which he devoted his life could be interpreted in sculpture. The colleagues of this pillar of scriptural orthodoxy recall that he beamed with pride at the achievement of his skeptical son. The boundary between generations had been broken. The life of the father's vision flowered in a completely new form. Concomitant with Granlund's reincarnation of his mythic tradition is the tradition of his medium—bronze sculpture. A Granlund hallmark is his use of the ancient lost-wax process, putting him in a succession of artists that goes back three thousand years. This seems like a long time until we recall that it represents only about 100 generations of artists. Granlund is acutely aware of those generations. He likes to say that we stand on the shoulders of all the artists that have come before us.

During Granlund's years of study in Florence and Rome (1954-55, 1957-59), he touched the boundaries of parents like Donatello, Michelangelo, Raphael. In Milan, he became furious when he discovered that Degas "had done what I was up to and had

Life Tree, 1986
32 inches

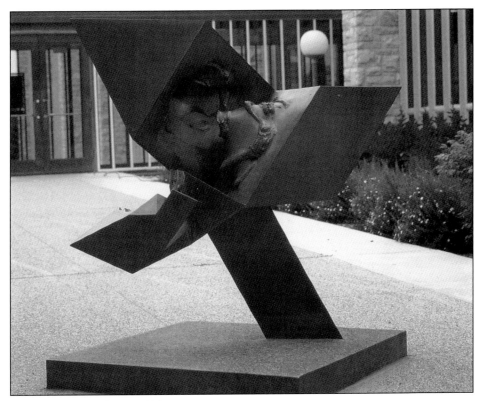

Celebration–Creation Element, 1980
5 feet

done it so damned well." And that touch was transmitted to the sculptors standing on Granlund's shoulders. Nick Legeros likes to think of the "apostolic succession" he participates in as a student of Granlund, who was a student of Gregory,[3] who was a student of Milles,[4] who was a student of Rodin.

The apostolic succession allows the shaman to cross the boundaries, but Granlund does not come back from that journey as Rodin any more than the bishop brings back Saint Peter. The organism is a new individual in each generation. This principle of continuity and change is what Saint Paul tried to exploit when he encouraged the Athenians to continue their worship of their "unknown god," while challenging them with a revolutionary vision of a god who dwelt not in shrines made by humans, but a God who lives within humans themselves. That kind of vision, an idea of a divinity with whom one's relationship is not mediated by external powers, is part of Paul Granlund's reinterpretation of the faith of his fathers.

For Granlund all art is celebration, so it is particularly apt that his most complicated and profound faith statement is the sculpture called *Celebration*, a four-part invention that straddles the administration building and the student union of St. Olaf College in Northfield, Minnesota. The first piece of *Celebration* is a five-foot sculpture named *Creation* (1980). *Creation* traces the generations back, not three thousand years, but

The Big Bang is still going on, the universe is still expanding: we are present at the moment of Creation.

twenty billion years, to the beginning of the universe, the beginning of life, and the beginning of salvation history.

The basic shape that unifies the four elements of *Celebration* is the tetrahedron, the four-sided structure, each of whose faces consists of a triangle. The tetrahedron is a good shape to use to sum up creation because it is the simplest geometric solid, the first of the regular solids contained by equilateral triangles, and the basic structure of most minerals. Silica tetrahedra are the basic building blocks of earth's crust. In addition, the tetrahedron suggests the tetractys, the arrangement of the first four numbers, which the ancient Pythagoreans regarded as the source of all things. What particularly intrigued Granlund about the tetrahedron is that if it is cut through at a certain angle to open the tetrahedron up, a square is revealed. A square inside a triangular shape seems profoundly mysterious.

In *Creation*, Granlund split the tetrahedron in half and then in half again, opening up each quadrant to reveal at its center a wealth of life-forms ranging from the most primitive sea creatures to the most beautiful shape life can take, that of the human body. Among the shapes revealed in the splitting of nature's tetrahedron is the egg. And Granlund's egg is itself split open to reveal two human beings whose images fit together in perfect symmetry.

Creation includes symbols of the most intriguing ideas of contemporary cosmology, of astronomical phenomena like spiral nebulae and black holes. The sculpture even includes fossil imprints of the artifacts of human ingenuity, as if the detritus of advanced civilization was present at the moment of Creation. The Big Bang is still going on, the universe is still expanding: we are present at the moment of Creation. The shaman has traveled through a black hole and made Creation a present moment. Among the primitive life forms Granlund includes are such things as imprints of labels of a Coca-Cola bottle and of Ivory soap, "99 and 44/100 percent pure." God saw that it was good (or at least 99 and 44/100 percent good). Another amusing touch is Granlund's inclusion of a Lava soap label together with a representation of Mount St. Helens.

Celebration–Creation Element,
detail

From the site of *Creation*, one sees the second element of *Celebration*, a piece called *Resurrection* (1981). *Resurrection* also uses the tetrahedron shape, but only one figure emerges from the square in the split triangle: the vast multiplicity of all creation is now summed up in the figure of the rising Christ, the New Creation. Emerging from a tomb made of the geometric shapes at the heart of crystalline nature, Christ stretches with a dancer's arms from the fetal shape of burial, like a flower opening in spring. This is the "raising from the dead" with which Saint Paul concluded his speech in the Athenian Areopagus, the Resurrection which made some mock, some wonder, and some follow Paul.

Celebration–Resurrection Element, 1981,
22 feet

Walking from *Creation* toward *Resurrection*, one must enter the glass-walled hallway connecting St. Olaf Center with the Administration Building to see that the *Resurrection* sculpture is on a sixteen-foot column, elevated above the courtyard. *Resurrection* faces the northwest in the direction of the third and fourth elements of *Celebration*, namely, *Community* and *Crucifixion*. It is necessary to walk to the ground level to enjoy the rest of the sculpture.

From the foot of *Resurrection*, one walks northwest, to view *Crucifixion* (1981), a twelve-foot sculpture depicting the Body of Christ, shattered by the results of sin. The figure of Christ is a collection of disconnected members, in a cubist montage. Tortured by the severing of the relationships that make humanity one, the figure is at the same time bursting forth vigorously as if the agony of sacrifice releases creative energies.

As the first element of *Celebration* represents the first Creation, *Crucifixion* represents the new Creation. Reinforcing this idea, Granlund reminds us of the egg in the sculpture *Creation*, by imbedding a human figure in the fetal position into a slice of opening tetrahedron, to the right of the severed body of Christ. The figure is reminiscent of Leonardo's drawing "Embryo in the Womb," in the position of sleep and the promise of awakening to new life.

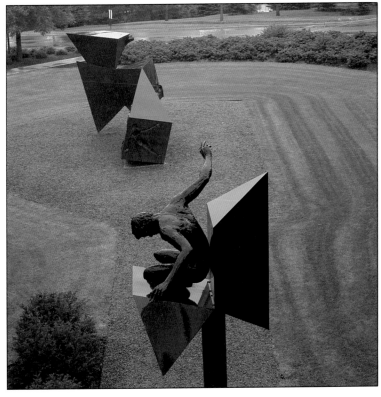

Celebration–Resurrection, Community,
Crucifixion Elements, 1981

Celebration–Crucifixion Element, 1981
12 feet

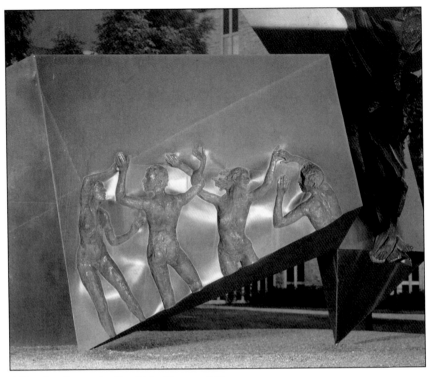

Celebration–Community, Crucifixion Elements, 1981
12 feet

Behind *Crucifixion* and connected to it is the fourth element in the sculpture series, *Community,* an elongated tetrahedron, reaching out eighteen feet toward *Resurrection.* In its sides Granlund imbedded imploding images of humans dancing because, he says, "Luther spoke of the saved as a community full of joy—like a community of dancers." At the southern end of the *Community* tetrahedron stands a female in a square, evoking Leonardo's human with outstretched limbs circumscribed by a circle. This archetypal figure pairs off with the parallel Christ figure at the other end of *Community* to form a frame for the humanity that dances in between, that humanity that is female just as it is male.

The female and male molds of the human community dancing from *Crucifixion* to *Resurrection* complete Granlund's version of salvation history. St. Olaf students like to come and pose, whimsically inserting their bodies into the imploded molds of humanity in *Community.* Granlund loves this, because not only does he mean all his sculpture to be touched, but he also means for his sculpture to touch us. As the students in their high spirits posture within *Community*'s bronze, they are making a statement about their place in the human community which is always in transition from Crucifixion to Resurrection.

Community is in one sense what *Celebration* is really about, just as all real celebration is about community. "Celebrate" is a Latin word that means to fill a place, to come together in large numbers, to frequent, to join with one's community for a feast.

Celebration is the explosive joy of a traditional family at a wedding or a first communion, amid the warm, embracing dancing of dozens of those to whom they are related by blood or love or both. To celebrate is to be in community. Christians *celebrate* the Eucharist, which is not a private affair with God, but Communion. And while it is true that in the depth of one's soul all grief is private, humans must mourn the loss of those they love, in community, at a funeral. Celebrate we must—we really only exist together.

Celebration is not just Granlund's statement about the universe and human life. It is a nonlinear interpretation of salvation history, unlike the logical sequence of events taught by the catechism, "from Genesis to Revelation." From *Creation* one cannot see *Crucifixion*. Likewise from *Crucifixion*, one might never know that *Creation* existed. It is only at *Resurrection* that one sees all of *Celebration*. But *Community* is connected to *Crucifixion*. New life is born from death. Behind the severed Body of Christ are the dancing figures of the new Creation. *Community* flows from *Crucifixion* toward *Resurrection*, from the suffering and death of the past toward the new life that is yet to come.

Central to the entire structure of *Celebration* is *Resurrection*. It is the pivot for the line that runs from *Creation* to *Crucifixion*. Creation itself, of course, is not an historical event that happened twenty billion years ago. Creation is what is, as in "All Creation," from amoebas to zinnias, from the mitosis of the egg to the dancing figures swirling about a spiral nebula at the heart of Granlund's *Creation*, and from primitive sea creatures to the mostly pure Ivory soap label.

The location of *Celebration* is important. In order to get from *Creation* to *Community*, one has to go through the actual buildings that separate the elements of the sculpture. These are the spaces in which St. Olaf College carries on its public life. And at the spot where the beam formed by the administrative and student centers intersects with the four parts of *Celebration*, Christ is in the process of rising from the tetrahedron.

From tetrahedron to tetrahedron the shaman has crossed the boundaries all the way back to Creation. The food, the fertility, the shocking news that he brings back is that the creation of all is the joyful dance of hands touching hands at the ultimate boundary, the great hora that makes the beginning time the present time. The shaman's gift, brought back to save the community, is the very crossing itself.

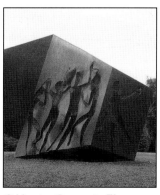

Only the shaman can dance across that boundary. At the end of the creation of a sculpture, Granlund asks himself, "Does it sing?" If it sings, Granlund knows his hands have danced to the other place. Those are the hands that made the seven pairs of hands, holding friends in the weightless dance of *Constellation Earth* (see next page).

Celebration–Community Element,
detail

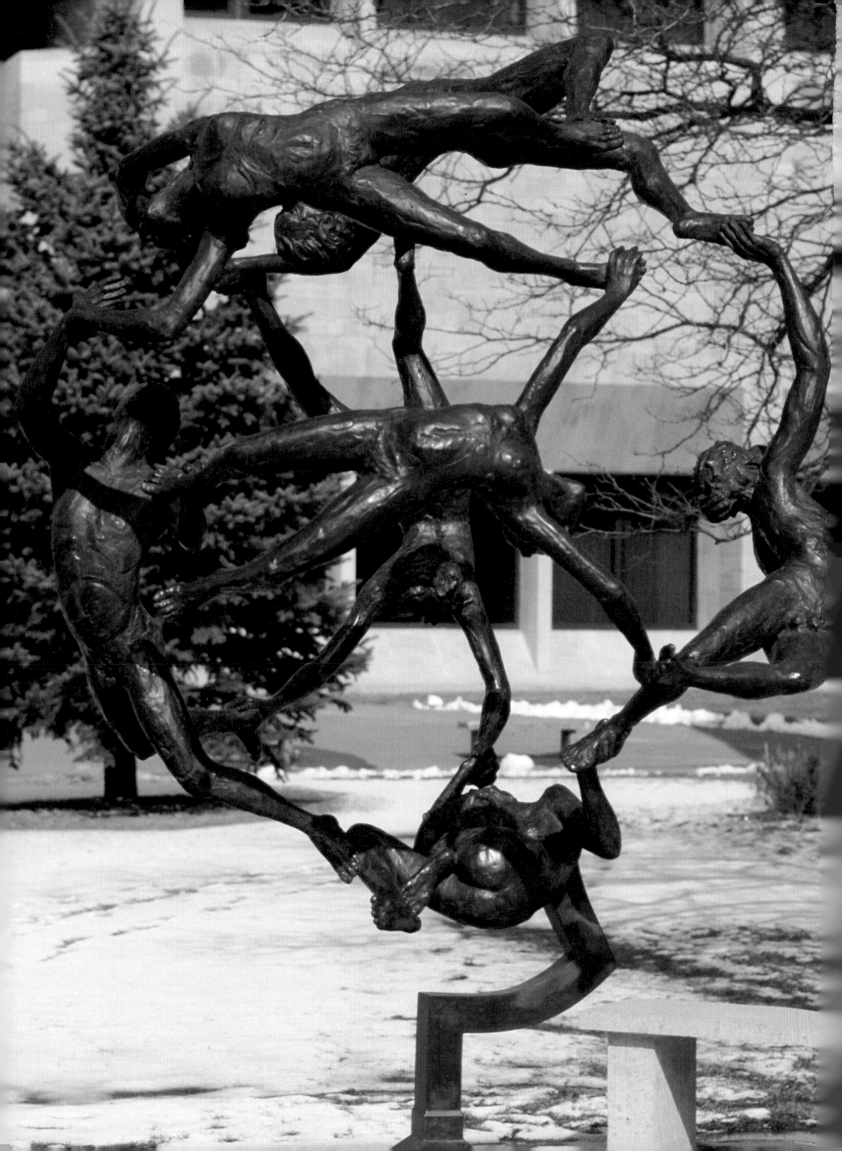

Cosmologist: The Unifier

Paul Granlund is a cosmologist. His medium is bronze, but his bronzes transcend the temporal boundary-crossing of past and future and turn time into the spatial relationship that we know it is.

When Granlund stares into his telescope at the heavens he is amazed at the proximity of the moon, the other planets, the constellations. Their presence is palpable, for all that separates them from us is time. Twentieth-century physics shares with ancient mythology the conviction that the cosmos is one and that the elements that fuel micro-organisms are born in the stars. The mythopoet is the cosmologist. Reality is four-dimensional, and we touch in all directions.

It is only the human mind that is aware of the infinity of relationships among the force fields of the exploding universe. It is only the human being who explores the microscopic details of its own organism with the same fanatical precision with which it counts the stars. The human eye is the transition point between telescope and microscope. We see it all. Contemporary chaos theory is confirming what humans have always (except during the brief hegemony of positivism and determinism) known intuitively: it is metaphysically impossible for us to count all the relationships. But we can *know* the relationships. And the reason we can know the relationships is that we can tell a story. For the poet, for the shaman, for the cosmologist, it is the human body that unifies all reality and allegorically personifies all relationship through story.

Constellation Earth (1984) is a sculpture that looks at our planet from outer space/time. Seven human planets float freely in space, but touch one another to form a sphere. Every human being is a star, and together we form a constellation. But the constellation that the humans in this sculpture form is our own Earth, the globe that gave us birth and is the center of our universe. Granlund says that *Constellation Earth* is about being in the middle of the universe. The mystery of individuation is about being in the middle of the universe. The sculpture, like many Granlund pieces, is a microcosm that expresses cosmic relationship in terms of human spirit.

◀ *Constellation Earth*, 1984
 8 feet

Every human being is a star, and together we form a constellation.

To Granlund, weightlessness is a metaphor for freedom. The seven human spirits that float weightless and free in *Constellation Earth* are young people, nubile and ephebic, energetic and potent. They are Earth's seven continents, held together by the invisible gravity of an invisible earth—and by the touch of hands and feet. They float freely in space/time like the continents that ride their plates about Earth's molten core, continents connected for the most part only by the touch of human and animal congress. Each person is a continent—each continent is a planet—each planet is a star in the Constellation we call Earth. The interdependence of Granlund's human planets holds the earth together in a symbiosis of centripetal gravity and centrifugal freedom. The pull of gravity results in the sphere, and the explosion of freedom creates the spirit.

At the dedication of *Constellation Earth* at the University of St. Thomas in St. Paul, Granlund pictured himself standing in the center of the sculpture as he modeled it. Touching both North America and Asia simultaneously, he envisioned the continents of humanity as constellations in the sky. Then, taking the opposite perspective, he was reminded of the theory that, if one could travel through the planet, being drawn to the core by the force of gravity and being repelled from the center by momentum, any journey to any other spot on the planet would take the same amount of time. All spots on planet Earth are equidistant from all other spots. Everyone touches everyone.

The seven human continents are not land masses so much as they are the peoples of the earth. The four female and three male bodies are partly allegorical. Female Antartica sleeps in the fetal posture so characteristic of Granlund's work. She is a special place, the continent around whom all the others clustered millions of years ago, the continent that humanity ought to leave alone in her majestic sleep, a place to remind us of the fragility of our mother, the Earth. Independent Australia is male; Asia and Europe, the connected sources of so many billions, are female; domineering North America is male, while its mate to the South is female; and energetic Africa is male. But the allegory of genders is relatively unimportant. This is a sculpture that tells the story of the cosmological conviction, the perception that the universe is one from the farthest red giant to the smallest electron at Earth's core. And, to paraphrase Protagoras, it is the human being that measures all.

Similar to *Constellation Earth* is *Anthrosphere* (1988), commissioned for the World Trade Center in St. Paul. (A small version of *Anthrosphere* was presented to Mikhail Gorbachev on the occasion of his visit to Minnesota in 1990.) *Anthrosphere* represents the seven continents as seven floating human beings, but this time the continents are connected by two-dimensional plates of bronze which recreate the oceans. These oceans are teeming with life—with crustaceans, with fish, with marine mammals. As one approaches *Anthrosphere*, the creatures in the oceans appear blurred. They have imploded into the two-dimensional plates, creating the effect, from outside the

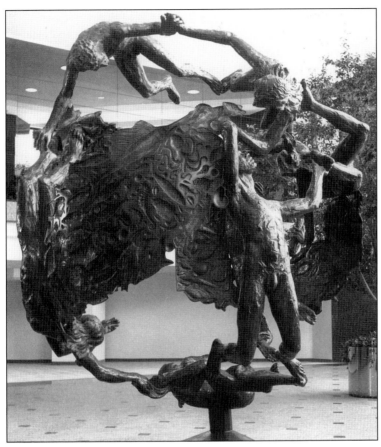

Anthrosphere, 1988
14 feet

sculpture, of the sea's wavy texture. But from inside the sculpture, under water, one can see things as they are, the sea life standing out in positive relief.

Constellation Earth has a distant perspective. Earth is conceived of as a constellation in the cosmos, a floating relationship of stellate humanity. Granlund says that he is in awe of being part of the universe: "all that space comes up and touches us right here." *Anthrosphere*'s point of view is from the other direction. The Greek title Granlund invented for it brings this perspective into focus: *anthropos* means "human being." The universe is human, the universe is alive, the universe is the relationships that join person with person and humanity with the surge of life from which it emerged.

The larger size of *Anthrosphere* makes it possible actually to stand inside the sculpture, and when one does so the temptation to reach out and touch the bodies of the continents is irresistible. This is a sensual sculpture—human limbs feel like real arms and legs. Each body (three males, four females again) touches the hand, the foot, or some other part of the body of at least one member of the opposite sex, and then of a

Children of God, 1990
9 inches x 10 inches

"I like having wilderness on one side and infinity on the other."

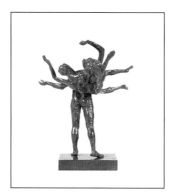

Corona, 1990
11 inches

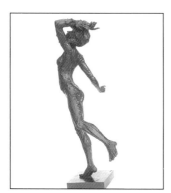

South Wind II, 1982
42 inches

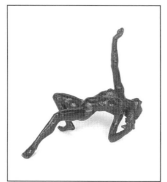

Iris, 1988
8 inches

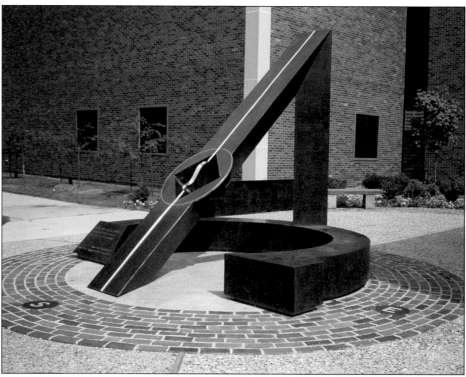

Alpha and Omega Sundial, 1989
9 feet 6 inches, bronze and stainless steel

second or third body, so that the entire Earth, the entire sphere is interconnected. Sculpting, Granlund says, helps him learn his "size in the universe." So does being at his home in Superior National Forest overlooking Lake Superior. "I like having wilderness on one side and infinity on the other."

Unity of space and time, that peculiarly human perspective on reality, is apparent again in *Alpha and Omega Sundial* (1989), commissioned by benefactors of Grinnell College in Iowa. The site chosen for the sculpture was circular, so Granlund envisioned cutting into that circle to allow viewing of the sundial. Cutting into a circle creates the shape of the Greek letter omega. Erecting the gnomon to cast the sun's shadow creates the shape of the Greek letter alpha. Alpha and Omega, the beginning and the end, sum up all reality.

A sundial measures time precisely by tracking spatial relationships on a calibrated plane surface. In the sculpture, the sun casts the shadow of the erect Alpha style onto the inside of an open cone, containing a gauge with numerical symbols from several disparate cultures from around the world. Time/space is measured only by humanity. The first Greek letter interrupts the sun's light all the way down to the last Greek letter, where human abstract symbols, from several continents of constellation Earth, tell the viewer just where we are in space/time. Granlund remarks that although his sundial will not tell time at night, "it reminds us that there is another place on Earth where time is exactly twelve hours different from ours."

Children of God (1990) is another Granlund work that attempts the miracle of sculpting light. Commissioned as a funeral memorial, *Children of God* makes death an instant in each human's life, for the sun's light and its shadows bestow sacredness on time. Granlund explains that the shadow of the children is imbedded in the base on which they stand, "but it is the shadow of their heads, from the top, as if we were looking down on them from above." Light, by being blocked, implodes the shadow of its blocker into and beyond the plane that absorbs it. The negative image of the childrens' heads appears at their feet.

The light of the sun is also blocked in *Corona* (1990). A corona is a luminous ring around a celestial body that is caused by diffusion of light. In *Corona*, Granlund has mythologized an eclipse of the moon. The heavenly body of Selene, goddess of the moon, is gently caressed by the touch of the light of the sun, a smaller male that hovers gracefully behind her head and gently kisses her shoulder. The sun is smaller because he is farther away from us. His torso is nearly hidden behind the moon he loves, and the halo he creates around her is punctuated by the solar flares of his arms and legs. As the Greek philosopher Empedocles taught, it is the forces of love and hate that cause the motions of all the cosmos. Every beloved is one with the moon, whose gravity tugs at the fluids of her body. Every lover is one with the sun, whose kiss brings warmth and generation, and the occasional disruption of satellite communication.

The sensuous kiss of the sun can be felt in *South Wind II* (1982), who, according to Granlund, "basks in the warm breezes of summer." With erotic abandon *South Wind I* floats weightless and free in the summer's languor, reminiscent of Granlund's sculpture of the goddess of the rainbow, *Iris* (1988). *North Wind* (1981), on the other hand, "is a figure that cringes from the cold." And "*West Wind* (1982) has started soaring on the wind." Finally, "*East Wind* is malicious, a judgment wind." Granlund created *East Wind* (1982) while struggling with the problems of a detached retina, suffered during a storm. *East Wind*, he says, is "almost a Medusa." Taken together, the four *Winds* run the gamut of human emotions, not so much anthropomorphizing nature as endowing the human heart with all the force of the natural world of which it is a part. Anger, joy, fear, ecstasy are the winds that make the human heart fly.

It is not only our emotional life that makes us intimate with the cosmos. In *Linnaeus (Head of Carl von Linné* [1988]), Granlund exercises his wit and ingenuity by mythologizing the great father of taxonomy. Created for the arboretum at Gustavus Adolphus College and The Linnaeus Garden in Uppsala, Sweden, the bust of Linnaeus is more than a portrait. In a playful comment on baroque coiffure, Granlund has planted the detailed arrangement of Linnaeus' own garden on the back of his wig. And the base of the bust is a tree whose leaves become the edges of Linnaeus' garments. The family's Swedish name was von Linné, "of the linden tree," and it was Linnaeus' father, a learned clergyman, who had taken the name and

Anger, joy, fear, ecstasy are the winds that make the human heart fly.

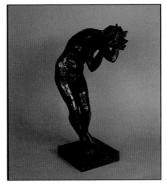

North Wind, 1981
21 inches

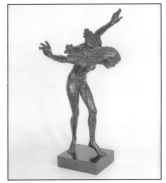

West Wind, 1982
31 inches

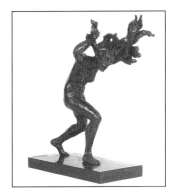

East Wind, 1982
11 1/4 inches

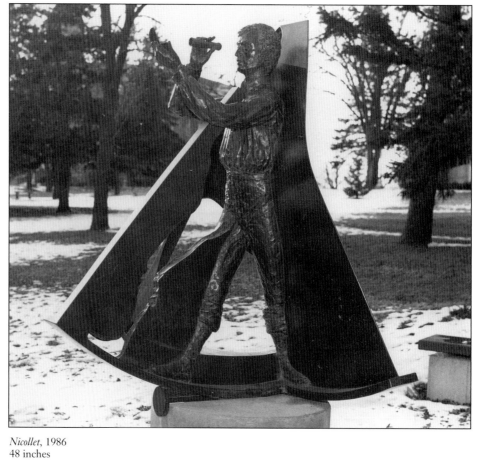

Nicollet, 1986
48 inches

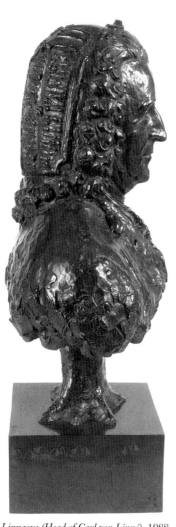

Linnaeus (Head of Carl von Linné), 1988
35 inches

Latinized it in keeping with tradition. So Granlund has returned the archetypal namer of trees and plants back to his roots. The head of Carl von Linné grows out of the trunk of a linden tree, and he presides impassively over the orderly arrangement of his own arboretum at the new world's premier Swedish college. One of the great figures of modern science has become a vegetation deity. Like a character from Tolkien, the treeherd has become the tree.

Another historical figure that Granlund has cast in his own milieu is the French mathematician and astronomer, Joseph Nicholas Nicollet. Nicollet became a cartographer for the American government and was the first to explore scientifically the upper Mississippi and Missouri River valleys. Prefigurative of Granlund's sundial-Alpha is the sextant in which he has framed Nicollet. As a cartographer, Nicollet made constant use of the navigator's sextant, putting his eye to glass to measure the altitude of stars and thus determine his location on Earth. In Granlund's *Nicollet* (1986), Heisenberg's uncertainty principle becomes bronze, as the measurer stands inside his instrument. We are what we measure. Standing in his sextant, in St. Peter, the seat of the county named for him, on the crest of the Minnesota River valley, Nicollet peers through his surveyor's scope across the valley that he actually charted a

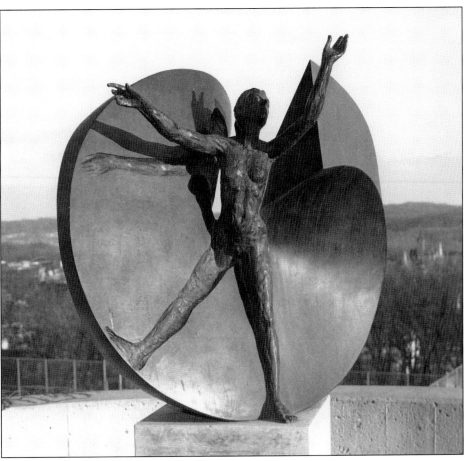

Venus Nautilus II, 1983
34 inches

century and a half ago. And in his left hand he holds a two-dimensional image of what he would have seen through the telescope.

Striding through his sextant, *Nicollet* reminds the viewer of one of Granlund's most widely known sculptures, *The Time Being* (1973), and of *The Time Being*'s sister bronze, *Venus Nautilus II* (1983). Influenced by Botticelli's "The Birth of Venus" and Leonardo's proportional drawing of man within a square and circle, *Venus Nautilus* places mythology within nature. In mythology, Venus was born from the spume of the sea. The lovely human female that is Granlund's Venus strides forth in freedom from the geometric spiral of the primordial chamber-building nautilus. As Granlund described her at the sculpture's dedication, "The Venus image appears first as an imprinted floating figure near the spiral's axial beginning. There are no confining chambers in this shell which is both cradle and spring. The full Venus figure emerges astride the spiral form, her reach extending beyond the radial surface imprints of dance and proportional measure, affirming the discovery and exercise of new dimensions of freedom."

The Time Being, 1973
12 feet, bronze and stainless steel

Gesture is "a structural answer to gravity, to the forms and forces in the universe."

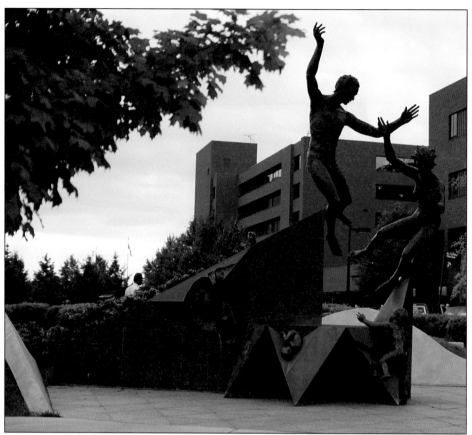

Wellspring, 1985
14 feet

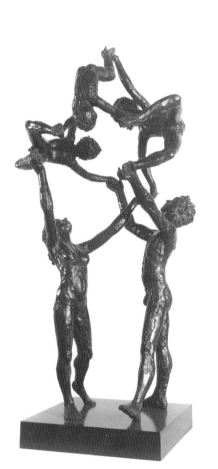

Familia II, 1986
48 inches

New dimensions of freedom are expressed as well in the spherical juggling of *Familia II* (1986). Granlund calls gesture "a structural answer to gravity, to the forms and forces in the universe." The gestures of the *Familia* parents defy gravity, as they gently lob their three children aloft in a cosmic sea. All parents feel at some time or other that they are juggling their children (or vice versa), but in *Familia* the gesture is carefree, joyful, and creative. Mother, father, pubescent girl, preteen boy, infant girl dance free of the constraints that weigh the human spirit down. Each parent has one foot planted firmly and one foot barely touching the ground, father at the heel, mother at the toe. Each parent holds a child's hand, as if offering a flower to the sky, rather than actually supporting the flying children.

The children of *Familia* fly of their own accord, touching parents for love's sake rather than for balance. The interlocking circles of arms and legs form a kind of gyroscope. The arched backs of the older children are a horizontal circle. The gyroscope is completed by the circles from father to son to baby to daughter to father and likewise from mother to baby and back again. Parents look up at their children in wonder. Children face outward away from the family circle, but glance back over their shoulders, son to mother, daughter to father. And baby hovers protectively at the top of the sculpture, curving inward and completing all the circles that compose this family's sphere.

Wellspring (1985) represents another family, but in this monumental sculpture, created for Abbott Northwestern Hospital in Minneapolis, the order of ascent to freedom is reversed. The ambivalence of life-death imagery permeates much of Granlund's work. In *Wellspring*, three fetal shapes are imploded into the surfaces of the splitting tetrahedra that open to reveal a pool and fountain. Then, a three-foot-high child climbs from negative to positive and reaches up to play in the fountain, at the water that is the source of its life. Above the child, out of the water of the fountain, two adults surge upward in freedom and in the health that the sculpture's title and location portend. From the womb of life, the human being grows through time into space, and then returns to the earth, imprinted as a fetal death shape.

To the viewer standing at the foot of *Wellspring*, the adult seems to fly off into the sky. Soaring into a sky of freedom is also the gesture of the dominant figure of *Birth of Freedom* (1976), the monumental sculpture commissioned for Westminster Presbyterian Church and punctuating the southern end of Nicollet Mall in

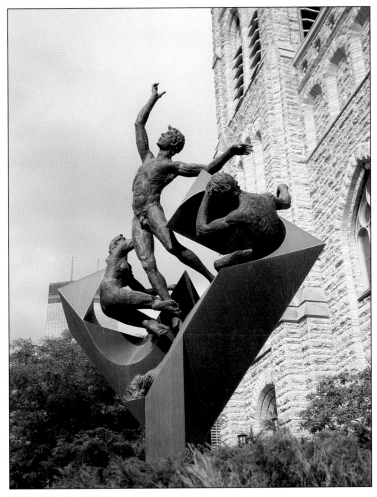

Birth of Freedom, 1976
17 feet 6 inches

The dreamer dreams herself, as the artist creates herself, as the human being frees herself.

Tiny Alice I, 1965
9 1/4 inches

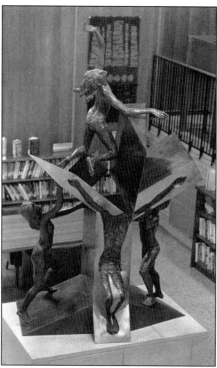

Founders, 1979
8 feet 6 inches

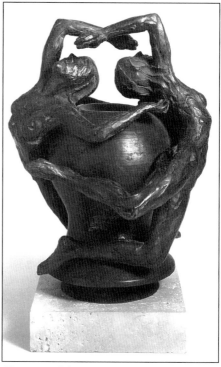

Figures on a Sphere, 1966
15 inches

Minneapolis. In *Birth of Freedom* a cube splits open to reveal a sleeping figure at its base. Two other figures emerge from that sleep and grow into the jubilation of the victorious freedom figure at the top. *Birth of Freedom* is perhaps Granlund's most public statement of the human creative urge toward freedom, and the sculpture relates intimately to its own cosmos.

Birth of Freedom helps frame the public life of Minneapolis. Standing at the south end of the city's showplace, Nicollet Mall, the sculpture serves as a pivot for Minneapolis' promenade, for the front of the sculpture faces west in the direction of Loring Green, the Guthrie Theatre, and the Walker Art Center. Just across Twelfth Street to the north is the home of the Minnesota Orchestra. And *Birth of Freedom* reminds the viewer that just a mile away the north end of Nicollet Mall is punctuated by Granlund's *The Time Being* (1973). *The Time Being* itself is cosmological. In Granlund's words, "Man, the measurer of time and space, who used the square to measure the globe and the circle to measure the edge of the universe, also measures his own value. This sculpture celebrates man as the value-maker whose reaching energy and imagination exceed the limits of his own self-imposed systems."[1]

Similarly emerging figures integrate the parameters of time and space in *Founders* (1979). Commissioned for Concordia College in Moorhead, Minnesota, *Founders* is an anniversary sculpture that brings the school's founders to life as contemporary human beings who emerge from ancient Greek geometry. The founders of

Tiny Alice II, 1967
18 inches

Concordia College are not nineteenth-century graybeards but the contemporary scholars who continually re-found the institution of learning in each new generation. The Pythagorean theorem becomes bronze as triangles are measured and split to reveal a Christ figure imprinted in the structure of reality and human beings exploding with the lessons of freedom.

Geometry is also present in *Figures on a Sphere* (1966). Two young women float freely with their backs curled around an ovoid shape that suggests a head as much as it does the sphere of Earth. It is in the human head that both freedom and geometry lie. In *In the Round* (1980) a woman forms a sphere by arching her back until her hands touch her feet. Geometry also plays a part in *Tiny Alice I* (1965), in which the woman's head can be seen *inside* the sphere, as if her head is in her head. This suggestion of infinite regression is developed in a different way in *Tiny Alice II* (1967). Although inspired by Edward Albee's play, these sculptures are not about corruption, but about interiority. Albee's notion that we live in the models we make is transformed by Granlund into the suggestion that we are the art that resides within us. In *Tiny Alice II* that art is not just mental (in the sphere of the head), it is corporeal. Tiny Alice lives in a box which is the torso of less Tiny Alice, who lives in a box which is the corpus of Granlund's sculpture.

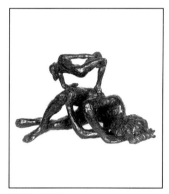

REM, 1978
6 1/4 x 12 1/4 inches

We see the sculpting of thought again in *REM* (1978), whose title suggests "rapid eye movement." The subject is a dreamer and the figure she dreams is a miniature (and inverted) version of herself. The dreamer dreams herself, as the artist creates herself, as the human being frees herself. This Heisenbergian relationship between thought and the self can be seen again in the sculptures called *Reflection*. A woman sits pensively upon a geometric base which still contains the mold of her own body. She has emerged from the clay out of which she was molded and is reflecting upon her origins. Thought is physical, not just cerebral. Emerging from the clay of mother Earth, we drag that clay with us and we use it to fire neurons and reconstruct ourselves within ourselves. Granlund always carries in his wallet, like a talisman, a newspaper clipping that reports certain scientists' theory that life first emerged from clay, a substance that (like the soul of an artist) has the capacity to store and transfer energy. Clay stores the energy with which the sculptor endows it. Then it transfers that energy to bronze, the molten fluid that is the sap and blood of mother Earth.

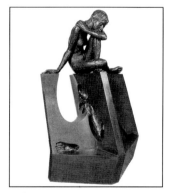

Reflection III, 1979
66 inches

Totem (1976) is a sculpture that portrays the transfer of energy. It is about growth and the sun—about our planet's basic elements, earth, air, fire, and water. A totem is an attestation of ancestral relationship. *Totem*'s abstract wave patterns suggest the wavelengths of light, the swirl of water and air, the motions of Earth. A human figure is imprinted on the shaft of the sculpture, both in the positive condition of matter and in negative absence that is antimatter. *Totem* glorifies the energy of life. The energy of life, sparked by the touch of the sun, is what inspires the dancing of *Saint Francis* (1989) (see next page).

Totem, 1976
18 1/4 inches

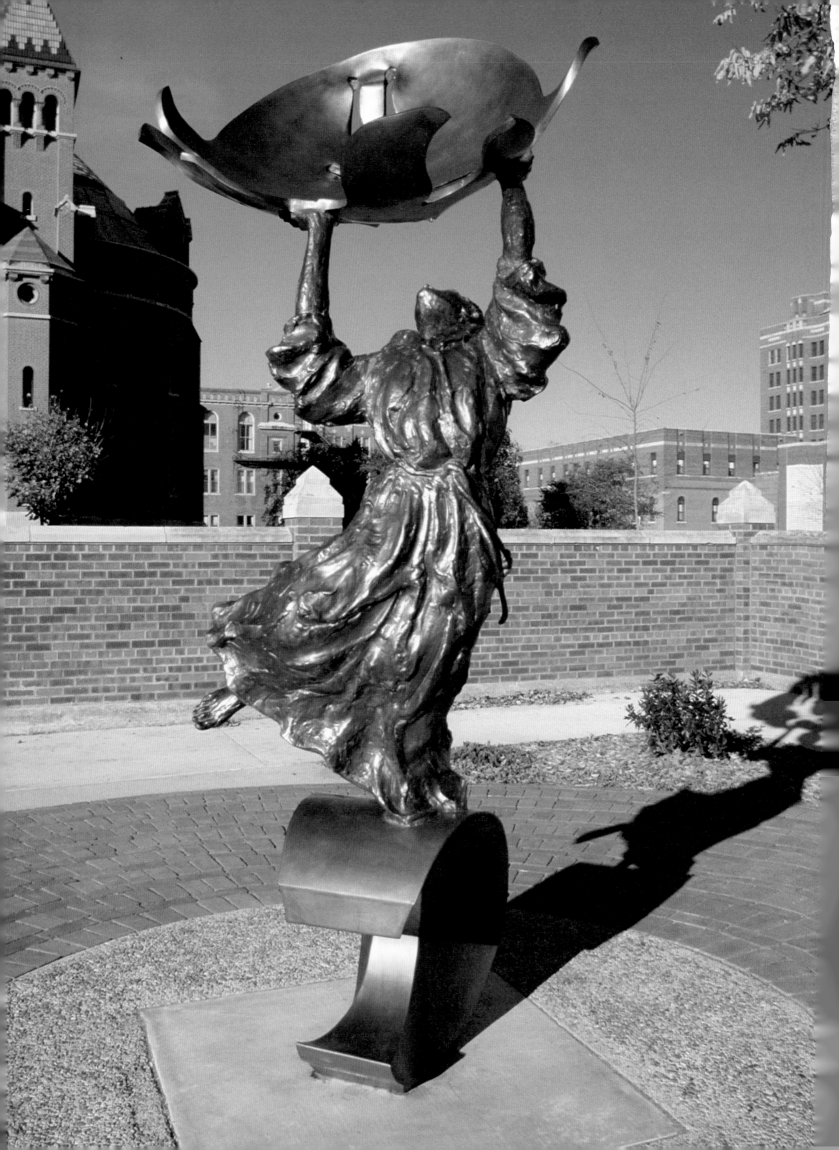

UNMEDIATED SPIRIT

If there is one religious hero who is most appropriate for Granlund to portray, it would have to be Saint Francis of Assisi. More than any other figure, Francis represents both humanity's fundamental spiritual insight and a profound indifference to the institutionalization of that insight. When his father hauled him before the Bishop of Assisi to pressure him to abandon his excessive almsgiving, Francis symbolized forever his disdain for wealth in the notorious gesture of stripping naked. Neither love for his father nor respect for his bishop prevented him from demonstrating his embrace of the principle of total renunciation of the "goods of the material world." But Francis' asceticism is not dualistic. He renounces the world, not the earth. The oldest Italian poetry, antedating Dante by half a century, is Francis' famous "Canticle of Brother Sun," that moving hymn to earth, air, fire, and water—to love and to death. Francis is a poet. Francis is a shaman, crossing to the other side. Francis is a cosmologist, who knows he's made of the same particles as Brother Sun and Sister Moon. Thus Granlund was delighted to be invited to bypass the traditional iconography of Francis as a monastic Dr. Doolittle preaching to the animals. Instead, Granlund's Francis dances on the moon and juggles the sun.

Saint Francis is praised as an early environmentalist, but his relationship with the earth sprang from an intensely incarnational spirituality. It was the presence of the divine in the earth that made Francis strip off the world to embrace the earth. And "the world" for Francis was not just his father's wealth. He even stripped himself of control of the Order he founded when its chapter rejected his prescription for absolute poverty. And he rose from his deathbed, removed his habit, and lay down naked on the bare earth in order to return the way he had come.

Unlike many reformers, historical and contemporary, Francis was anything but dour. He sang and danced for joy. He did not want his order to become scholars, but encouraged them to travel around singing. Francis sang uproariously on his deathbed, despite the censure of his superior who thought the founder of a religious order and a famous mystic ought to die more decorously.

◀ *Saint Francis,* 1989
 9 feet

Granlund has sculpted the divine as pure light — the energy that is not there, but whose effect is palpable, penetrating and permeating all.

And Francis danced. Early in his career, Granlund began musing about the "shape of joy." For many, his dancing *Saint Francis* is the epitome of the saint's joyful vision. The sculpture is the pivot of Assisi Court, the central quadrangle of Viterbo College in La Crosse, Wisconsin, in a space that is appropriate to the generosity of Francis' vision and surrounded by buildings that sum up the Franciscan tradition of piety, the arts, and service. There Francis dances on the moon, balancing dangerously, his foot merely grazing the rolling moon. The crescent moon waxes and wanes, always changing, always rolling under Francis' shuffling feet. And Francis juggles the sun, his brother, into whose eternally round mirror he gazes with profound joy. The source of Francis' joy is the figure that for him symbolizes the presence of the divine in the earth: Jesus, the Christ. The wounds of the crucified Jesus burned into Francis' own hands and feet, a mystical experience that marked him forever. The stigmata are an external symbol of the burning of the divine into the heart of Francis. In the center of the ball of the sun is the image of the Jesus with whom Francis became so graphically identified. Francis stares not at the sun he plays with, but at the Christ in the middle of that burning star. The hands of the dancing Francis touch the sun at the spot where Jesus' hands are extended.

We look at that Christ figure and see air, light, nothing. The Son of God in the sun Francis juggles is present but incorporeal, brilliant but transparent. Granlund has sculpted the divine as pure light—the energy that is not there, but whose effect is palpable, penetrating and permeating all. The hands of Francis touch and are burned by the intangible force that makes his heart dance. The presence of the divine is felt most profoundly in its absence. This is the core of Francis' vision, the source of Jesus' ethical doctrine, the essence of the most basic religious insight. Granlund's sculpture . . . of Francis' vision . . . of Jesus' teaching . . . is the simple abdication of all power. Francis' surrender is Luther's grace alone. And it is Jesus' *kenosis*, the stripping off of his divinity, to die as a criminal. This is the source of Francis' joy. His feet dance and his habit flies in the wind, because his hands play with the burning fire of the cross, and his eyes are riveted on the emptiness of the Jesus who is not there. The disk of the sun, the source of earthly energy, is the lens through which Francis takes in the universe.

"Dance is an art form that is close to the art of sculpture. Dance excites our eyes and our feelings for a moment in time that is unforgettable; sculpture is forever fixed in one position that can be looked at repeatedly and always reveal something new."[1] Granlund sees dance as essentially linked with his ideas on gesture and gravity. Ironically, when a sculpture is finished, he does not ask himself, "Does it dance?," but "Does it sing?" The grace that is at the heart of Francis' song and dance appeared in a much earlier Granlund musical sculpture, *Sonata* (1975). The first movement of *Sonata* springs from a halo of the sun. The sun's radiance becomes sound waves in Granlund's poem about the sculpture.[2]

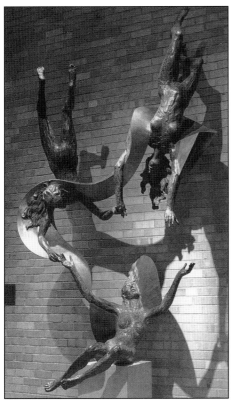

Sonata, 1975
10 feet 6 inches

SONATA—A SOUND PIECE

Translate wave and radiance of sound
into shape geometry—
space calligraphy.
Triangle and brass convolute
are cymbals of symbols—
seashell trumpets held to your mind.

Transpose a structured pose—
ecstatic aspects of one being
visually indivisible.
Three movement moments
reaching, touching and being touched
are rapt silent celebrations of sound.

"Three dimensions are an infinity of profiles, an infinity of two-dimensional views."

The Fine Arts Award, 1976
3 1/2 inches

The sun-halo that becomes a ribbon of sound waves entwining the three movements of *Sonata* is an abstraction, a bronze casting of an idea, a geometric illustration of an invisible force. The human intellect makes tangible a structure that can only be heard. The artist sings about the ineffable relationship that swirls from organism to organism. A ribbon of bronze stands for an energy that exists only beyond all sensation.

Sonata is reproduced on the Gustavus Adolphus College *Fine Arts Award* medallion (1976), surrounded by the infinity of a Moebius strip with the inscription, *cantare con spirito sonare*–"to sing with [the] spirit to play"—an ambiguous motto that runs in a circle and puns on the musical annotation, while suggesting the interior life that in*spire*s all artists—musicians, dancers, sculptors.

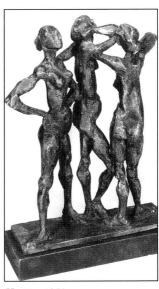

Vanities, 1954
6 inches

Sonata's three grace notes make up only one of several Granlund contributions to the perennially renewed ancient motif of the Three Graces, the attendants of Love. This theme runs from ancient Greek red-figure vases to Rodin, from Pompeian wall paintings to Picasso. The motif is a kind of allegory for sculpture, which breaks the limits of art created on plane surfaces, moving into three dimensions. In Granlund's words, "Three dimensions are an infinity of profiles, an infinity of two-dimensional views." Humanists have frequently allegorized the Three Graces as symbols of generosity, assigning them such names as "Giving, Accepting, and Returning" or "Chastity, Beauty, and Love." Granlund is not so explicit and mechanical, but the *grace* and *charm* of his sculptures capture precisely the etymological significance of the ancient words.

*Her play moved her father
to play at capturing a
moment at play.*

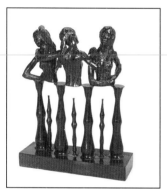

Trio, 1957
13 inches

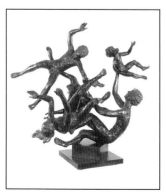

Swimmers, 1990
54 inches

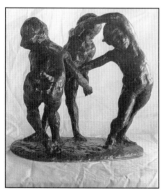

Pillar to Post, 1976
11 inches

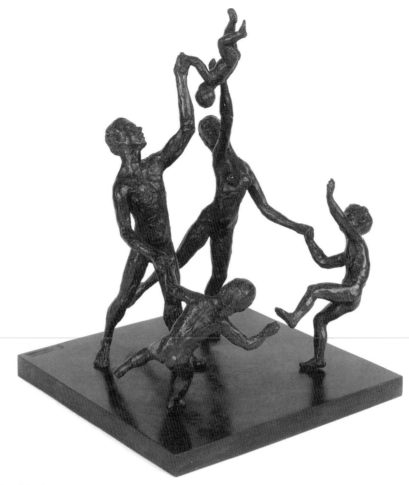

Lofting Model, 1991
13 3/4 inches

"Grace" is derived from the Latin translation of Greek "*charis*," charm, the free gift of the gods to those they love, the kiss that makes mortals beautiful. And "*gratia*" and "*charis*" are precisely the words used for the response of the recipient to the giver, namely, "thanks." In Luther's classic formulation, we are made blessed, "by grace alone," by a gift from the source of all, which we can do nothing to deserve. Existence is gratuitous. Grace is the charming gift of the creator and grace is what we say in return. For Christians, the ritual of the "Eu*charis*t" is "the Great Thanksgiving," a meal that puts communicants at the center.

All is gift. The charm of that realization comes through in many Granlund "Graces." Granlund's drollery appears in his first "Three Graces," *Vanities* (1954), three posers who take the traditional positions that allow the viewer to appreciate every side of the body from one angle of vision. The generosity of these beauties consists in sharing their arms. And Granlund's wit with words shows up in *Pillar to Post* (1976), three charmers who have to dance on legs of air. In *Trio* (1957), three putti dance on real legs in an interweaving hora that sings of giving, returning, and giving back again. These interlocking touches recur often in Granlund's corpus, from *Family* (1952, 1954 and 1974) and *Rondo* (1976) to *Singers* (1977), a group of seven females and males of all ages who dance while they sing. It is fitting that *Singers* graces the lobby of the Lutheran Social Service building to inspire those who serve there. The mutuality of the family of *Singers* recurs in the buoyant interweaving of *Swimmers* (1990) who cleave the water in a graceful ballet. The most recent creation of the aspirations that surge within multiple relationships is *Lofting* (1991), commissioned for the Miller-Dwan Medical Center in Duluth. Here, at an institution dedicated to

48

physical well-being, parents swing aloft the gift of their future, a baby girl, until she is almost upside down with glee. Meanwhile, each of two older children pull their parents off balance with a burst of jealous energy (Me Too!). Son tugs on Mother and Daughter on Father in that essential Granlund polarity that asserts the ambivalent tension of all relationship. The group forms a broken circle, with boy and girl leaving an opening for the viewer to enter the game, to play, to swing, to complete the orbit.

In *Flower* (1964), the dance of the Three Graces is metamorphosing into a flower. Granlund was inspired to do this piece while watching his young daughter, Gretchen, spin around at play. Her play moved her father to play at capturing a moment of play. Once asked if certain pieces were commissions, he replied, "No, they were just play." But in reality, every work he creates begins with play. Like grace, his work is gratuitous. Play, of course, is deadly serious. It was the pain of loss that inspired Granlund to create *For They Shall Be Comforted* (1986). In this bronze, beauty grieves over a dead relationship, on her knees, on her back, and on her face. Granlund's most recent and least unconventional version of the motif is called simply *Grace* (1990).

Winter and Summer Nymphs (1973), at the University of Minnesota Landscape Arboretum in Chanhassen, belongs to the circle of the Three Graces. While Winter curls up in the frozen earth in her frozen fetal posture of sleep/death, her three rollicking sisters dance ecstatically with backs arched and limbs flying. These are not, as we might expect, the other three seasons, but three angles of vision on the vibrant lushness of nature dancing with warmth and fulness. When the sculpture is covered with snow in typical Minnesota dress, the warmth of the dancers comes through all the more, and one wonders if these are not actually the nymphs of winter, since despite the weather they continue, in the poetry of Kathryn Christenson,

> those glib, silly siblings,
> dancing in this snow
> without their coats!

And is the sleeping nymph, then, a nymph of summer, who knows when to curl up in the womb, waiting for the other side of the cycle. What is she thinking?

> I will dance
> when bronze liquifies,
> when the axis of the earth
> tilts like a sculptor's crucible,
> when December
> brings arbors of Midsummer
> to the North Star State.[3]

The feminine grace of generosity, of giving love, of giving birth, of giving milk, appears again in the etherial beauty of *Sprites* (1969). The first casting of this piece

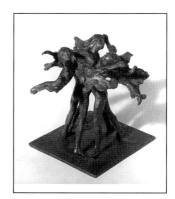

Flower, 1964
9 1/2 inches

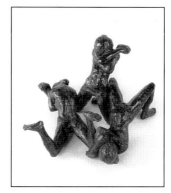

For They Shall Be Comforted, 1986
6 3/4 inches

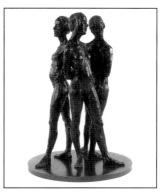

Grace, 1990
27 inches

"Maybe all my sculptures are a kind of birthday celebration."

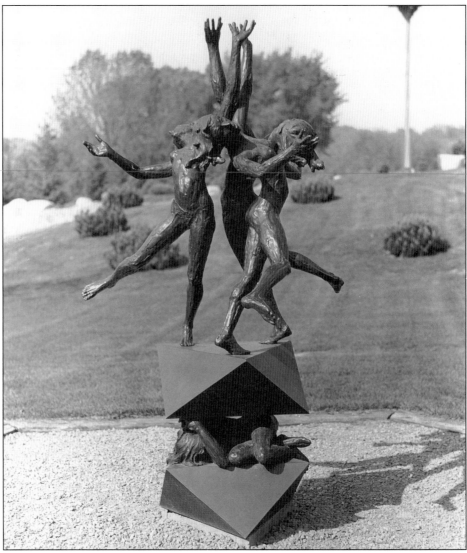

Winter and Summer Nymphs, 1973
6 feet

was commissioned by Metropolitan Medical Center (now Metropolitan Mount Sinai Medical Center) in Minneapolis, the hospital where Granlund was born. He sees it as a celebration of his being alive. In fact, he says, "Maybe all my sculptures are a kind of birthday celebration." The freedom of birth is intimately bound to Granlund's triadic bronzes. *Sprites* captures the feeling that comes from seeing one figure from three different positions in time. "I felt that that moment somehow of simultaneous knowledge was perhaps the reason for the freedom one felt looking at the figures and their movement."[4] "To have simultaneous visions transcends the space/time dimension normal to our lives."[5]

A second casting of *Sprites* commands the wide vista of a gracious mall on the campus of the University of Wisconsin at Eau Claire, and the sphere the dancers make floats

freely in space. *Sprites* presides over a fountain at its Minneapolis location, so there the nymphs are oceanids, swimming in a sphere of mutual giving. Taken together, the *Sprites* are space swimmers, swimming with the exultation felt by astronauts enjoying the freedom of weightlessness. For Granlund, the freedom of weightlessness comes not in the isolated idiom of a single springing, but in the reciprocal joy of relatedness: each Sprite touches her sisters' dancing feet (one of each). Each sister faces the world outside the sphere, yet the sphere exists only by the curves of the arched backs of the swimmers, who turn outward to us in invitation. "Come on in, the space is fine." It is indeed a fine space, a finite space, a space that suggests *infinity*.

For Granlund, the freedom of weightlessness comes not in the isolated idiom of a single springing, but in the reciprocal joy of relatedness.

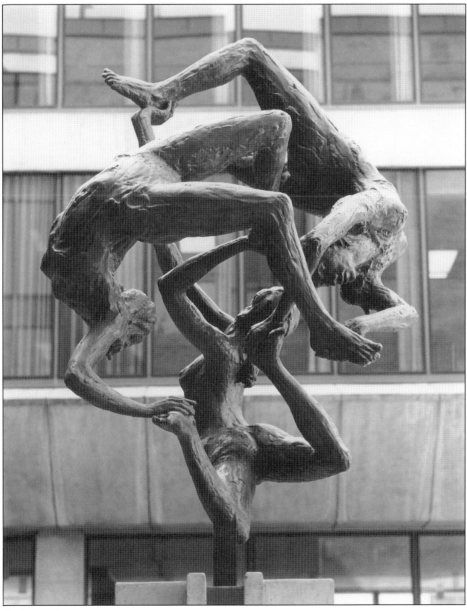

Sprites, 1969
8 feet

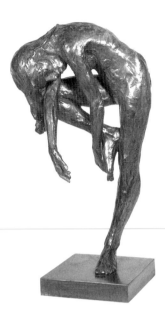

Figure on One Leg, 1973
18 inches

For the sphere of the *Sprites'* bodies goes on in all directions, hand to foot to hand, without a *finis*, without limit, as only the spirit can.

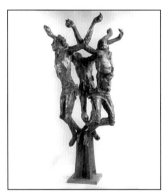

Crucifixion, 1964
60 inches

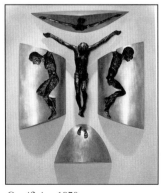

Crucifixion, 1970
42 x 36 inches

In *Figure on One Leg* (1973) a nude girl holds her foot and dances alone. She is a spirit about to spring to life. Her owner, theologian Robert P. Roth, says, "In a moment she will fling her head back and throw her arms up to signal her joy in being alive. Such relaxed equipoise does not come at the end of exercise. This graceful girl in balance is burning to begin."[6] *Figure on One Leg* was Granlund's response to Roth's request for a resurrection figure to replace another Granlund that had been stolen from his home. That earlier piece had been a model of *Crucifixion* (1967), commissioned by Roth's family for Luther Northwestern Theological Seminary in St. Paul. A nude woman dancing is as grace-ful a resurrection symbol as the figure of the crucified Jesus. That is precisely the reason that the seminary's *Crucifixion* is placed not behind the sanctuary altar, but in the middle of the congregation. Granlund's art is about "the intrusion of the gods into the affairs of men," it is about the presence of the infinite in limited humanity.

The "Three Graces" motif appears again in an earlier *Crucifixion* (1964), which depicts the two malefactors hanging from the same tree as Christ. In one case, grace is accepted, in the other it is rejected. Once again, the divine is in the midst of creation, for good or for ill. The tree of the cross is invisible, but Christ and the malefactors themselves become the tree. (This triple-crucifixion motif had also appeared in two earlier versions in 1953 and 1957.) A later *Crucifixion* (1970) uses a variation on the motif, with negative images of what at first appear to be the impressions of Christ's corpus on either side. But as Granlund explains, "they are the image impressions of two other figures—those of the malefactors. The moment of decision, whether to accept or reject Christ, is celebrated as well as the truth that

Christ died in our place, bore our griefs and carried our sorrows, that our empty state is the mold which Christ came to fill."[7]

That Christ is not alone on his tree is also apparent in *Cross Section* (1983), a ten-foot sculpture in which two prisms rise from a complex geometric base. As Granlund says, "Space shapes intersect the prisms at various angles and locations to form a composite cross of geometric masses and spaces."[8] Christ is invisible on this cross, just as in Saint Francis' sun. In his place are two human figures. A groggy male awakens at the

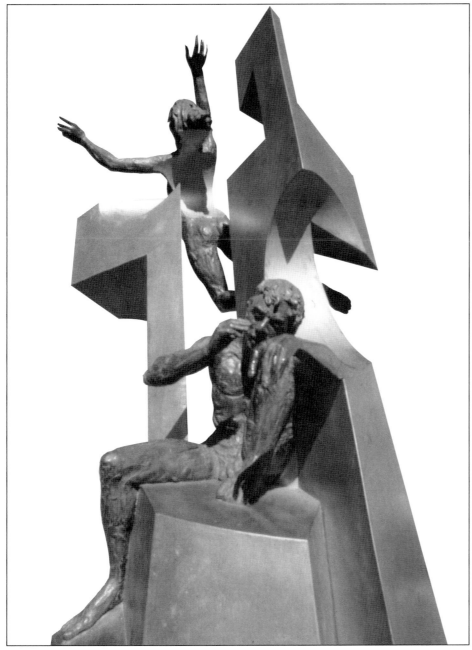

Cross Section, 1983
10 feet

Baptismal Font, 1983
57 inches

Bethesda Pool, 1981
66 inches

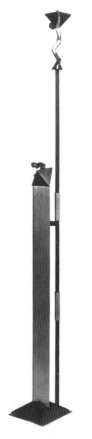

Crucifixion-Resurrection, 1982
7 feet 1 1/2 inches

base of the sculpture, while a soaring female flies upward in freedom, reaching beyond the structures of the cross. Inherent in every Granlund cross is a resurrection. The movement of the exultant female in *Cross Section* is reminiscent of the fluid movement of *The Way of the Cross* (1978). The flowing pattern is more like a river than a tree, and, here too, Christ is absent, except for the negative image left behind by his resurrected body. The waters of this cross reappear in *Baptismal Font* (1983), for the waters of baptism are the salvific waters of the basic Christian mystery. At the most ancient Christian ritual, that of the Easter vigil, the candle that symbolizes the light of Christ is plunged into the baptismal font. The phallic image of the source of new life makes fertile the archetypal womb of life, the waters from which all life emerges. The waters of Granlund's *Baptismal Font* flow from the cross and lead the newly awakened swimmer back to the cross. Water, the source of life that takes the shape of any container, the weakest of elements yet capable of overwhelming power, is a universal human symbol for that ineffable energy that is nothing yet divine.

The imagery of waters as healing occurs in *Bethesda Pool* (1981). Returning to the story in John 5 that had earlier inspired *Bethesda Angel*, Granlund sculpts the story's five porticoes in high relief, to frame the entire narrative, from the cured paralytic to the scandalized Pharisees. *Bethesda Pool* was commissioned for the Bethesda Lutheran Home in Watertown, Wisconsin. The home's residents love to touch the outstretched hand of Jesus on their way into the chapel, and have done it so often that Jesus' hand is polished a shining gold. Granlund means his sculpture to touch and be touched. "Sculpture is a tactile event."

"Reaching, touching and being touched," in the words of Granlund's poem on *Sonata*, are the defining activities of the human soul. That triple graced movement springs from the utter solitude of death and is completed in the melting of love. The love-death antinomy is inherent in every Granlund crucifix, each of which projects that resurrection that one senses in all he does. Sometimes the polarity is quite explicit, as in *Crucifixion-Resurrection* (1982), a processional cross in which the body of Christ hangs from an elongated geometric shape whose base consists of a fractured tetrahedron splitting to reveal the figure of the awakening crucified. This part of the sculpture, in turn, served as a model for two subsequent pieces titled *Resurrection* (1985).

A different depiction of life's polarities can be seen in *Cube Column Resurrection* (1991), commissioned for Roselawn Cemetery in St. Paul. Mounted atop a circular column are two cubes, each of which splits apart. At the rear of the lower cube the opening reveals the life-size form of a fetus, peacefully dozing in the womb of crystalline structure, promising more to come. Circling the sculpture, the viewer sees another fetal shape, this one the negative imprint of an adult body imploded into the surface of the cube, a silhouette of a burial, a burial in the posture of birth. But dominating

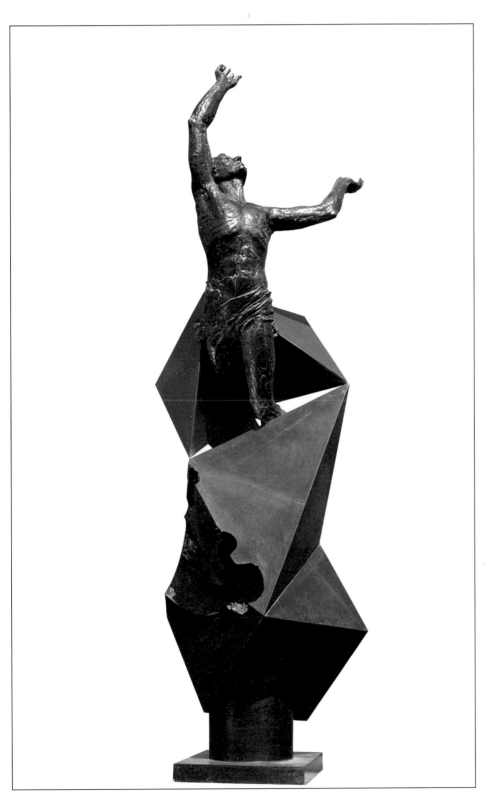

Cube Column Resurrection, 1991
14 feet 6 inches

Cube Column Resurrection, detail

55

the sculpture is the exultant body of a man surging upward out of the split in the upper cube. This rising figure captures one's mind and carries it soaring aloft to the tips of his feathery fingers, elongated to suggest flight. The man's torso stretches tautly as his abdomen is sucked up into his chest cavity—this is a leap that takes us with it. The reaching arms are curved slightly to suggest a circle, echoing the circle of landscape that surrounds the sculpture itself. It is this resurrection figure that one first sees, even from a distance. Only upon closer examination does one notice the fetus and the burial. That is as it should be, for the meaning of the resurrection is in the fetus, and the meaning of the burial is in the resurrection. Reality is a column, around which life spirals. Reality is three-dimensional like a cube, opening to the touch and shooting forth the reaching arms of the one who has been touched. Reality is a gift, and it is the "*gratias*" that we say in return. And Reality is the eternal relationship between grace-givers, the ineffable spirit that ties tomb to birth and birth to tomb.

Paul Granlund's tradition, like that of his forebears, casts humanity's spirit in terms of the mystery of the cross and resurrection of Jesus, but he is quick to point out that other traditions achieve the same fundamental human insight through other mythologies. "I don't know where that grace of God takes place, whether it is in the religion, in the genetic spiral or in man's mind as he tries to figure things out logically, but there seems to be an insistence that we continue on this life business." So artists are "meaning makers, creating some kind of mythology, borrowing from other myths and metaphors."[9] Granlund creates myths and metaphors for the transcendence of the human spirit.

The struggle of the human to overcome its limitation is dramatized in *Spirit of Courage* (1975), commissioned for Courage Center in Golden Valley, Minnesota, a rehabilitation organization that helps thousands of people overcome physical disabilities and get on with life. *Spirit of Courage* moves with flying legs that spin so fast they become a glowing spiral of sunshine. Arms are winged with flight, face is exhilarated with determination, and the pain of human limitation is no more. The freedom from bondage that is the goal of Courage Center is accurately summarized in Granlund's inscription for the sculpture, "The stamp of man's resolution to be free is the measure of courage."

It has been said that what impels the artist to create is a rage against death. Asked for a memorial for the deceased, Granlund combined the human form with the image of the moth as a resurrection symbol in *Luna Moth Matrix* (1980). The metamorphosis of the moth through its life stages represents the promise of renewal, of new life. Just as the spiraling disk of the runner's legs in *Spirit of Courage* captures all of the legs' space in one bronzed moment of time, so Granlund has sculpted motion by capturing the entire sweep of the moth's wings in a solid, massive, bronze unity. That wingsweep seems to wrap around the moth's torso 360 degrees, with splits in front

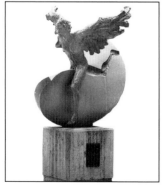

Spirit of Courage, 1975
53 inches

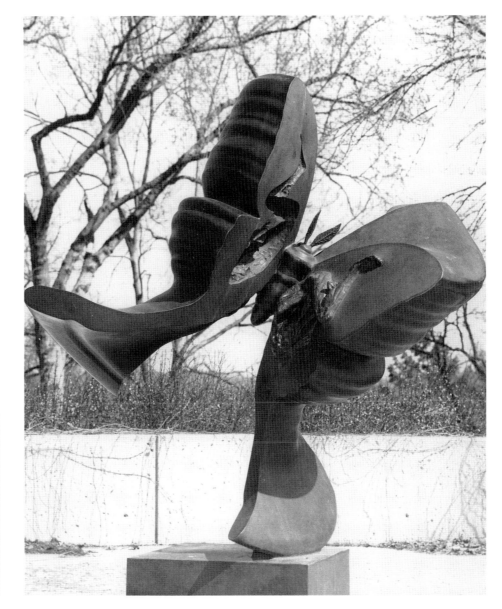

Luna Moth Matrix, 1980
5 feet and detail

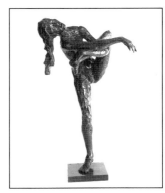

Earth Hostage, 1985
22 1/2 inches

and back. The entire space traversed by the flapping wing is caught in a solid alate unity. The cyclic figure of the moon on its wings (which gives the moth its name) is replaced on the sculpture by human symbols of life's cycles. The front of the sculpture reveals the cast of a male in fetal posture on one wing and the negative imprint of his body on the other wing. The underside of both wings, revealed to the viewer walking around the sculpture, contains the implosion of the body of a female flying in liberation. One side is being born, the other borne aloft. One side is male, the other female—but each wing holds the image of each gender; that is, if one swept through time with the flapping wing, one would go from one gender to the other. Universal human nature is the moon that waxes and wanes on the wings of the space/time life sign.

*Lovers kiss at any moment,
as an undeserved gift, and
not by appointment.*

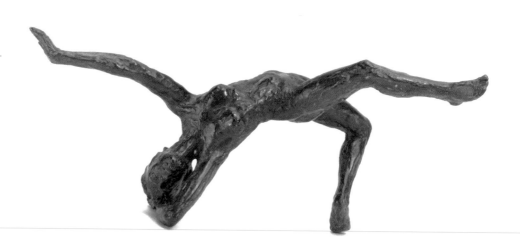

A Muse, 1990
10 1/2 inches

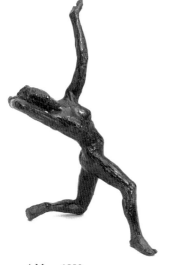

A Muse, 1990
10 1/2 inches

The female that has fled from *Luna Moth Matrix* reappears in *Flight* (1979-1980).
The spirituality suggested in Granlund's oxymoronic proclivity for making bronze fly
is hinted at in the problems raised by *Earth Hostage* (1985). Here a woman struggles
to free herself from gravity. She knots herself into a square post-and-lintel geometry,
striving for the etherial freedom of the lotus posture, but rooted to the earth by a kite-
string leg. Some of the same interlocking triangles of limbs appear in *Suspended
Animation* (1985), but here the soul (*anima*) has ceased its struggle and floats in a
time/space where gravity is suspended. Simliar freedom is felt by *A Muse* (1990), who
enjoys rotating her languorously outstretched body into three different positions,
including on her head. Thus *A Muse* becomes Three Graces. *B Muse* (1991) is
puzzled by this same ability in herself, bemused by the eternal triangles of her
involuted body. *A Muse* is similar to *Iris* (1988), the messenger of the gods. Someone
is trying to tell us something.

The triangles of *B Muse* and the floating of *A Muse* are combined in *Horizontal
Lovers III* (1986). These floating lovers are bemused by one another, suspended in
space and suspended in time at that perfect moment of the anticipated kiss, a perfect
moment that will never vanish. The timeless kiss is also the subject of *Impromptu*
(1986), a pair of lovers who recline horizontally as well as soar vertically. That's part
of why their kiss is *impromptu*, caught on the spur of the moment, unrehearsed,
spontaneous. The etymology of the word (Latin *prompt*) means "ready," as lovers
always are. They kiss at any moment, as an undeserved gift, and not by appointment.

Thunder and Lightning (1989) seem headed for a kiss—or some kind of fireworks. The
tension of polarities that is endemic in Granlund's work is apparent here. Male and
female are locked in balanced symmetry. They face away from each other and their
arched backs form a gyroscopic sphere. As they spin, almost *en pointe*, they twist their
heads around to meet one another's gaze, to reach for the touch of lips that fit each
other. But these are not male and female, opposite and complementary organisms;

A Muse, 1990
10 1/2 inches

rather these creatures are *Thunder and Lightning*, two manifestations of the same meteorological phenomenon as perceived by different senses. Thunder is the sound of lightning and lightning is the sight of thunder. Here the poet and the cosmologist agree. Here sexuality becomes spirit and the human organism leaps into that blinding light that is ineffably Other. Spirit lies in the relationship between Thunder and Lightning—and that relationship is a kiss.

Architect Edward Sovik observes, "What is inescapable about Paul Granlund's work is the persistence of the human figure." Almost equally pervasive in the Granlund corpus is the presence of abstract geometric shapes like the cubes in *Cube Column Resurrection*. These shapes, while sometimes reflecting the crystalline structure of natural elements, are essentially the imprint of the human intellect on experience. Geometry is an aspect of culture: only humans prove the Pythagorean theorem. Out of these products of intellect, Granlund makes the human form emerge, or dance, or leap.

The spirit leaps beyond the mind and its rational analyses. The spirit frees itself from the limitations of the particular. The spirit sheds the worldly wealth of physical, emotional, and intellectual habit. The spirit lies down naked on the bare earth. The spirit sings with uproarious joy at the gift of giving away all. When that is done, all that is left is the giving, the blinding light at the core of the juggled sun.

The spirit frees itself from the limitations of the particular.

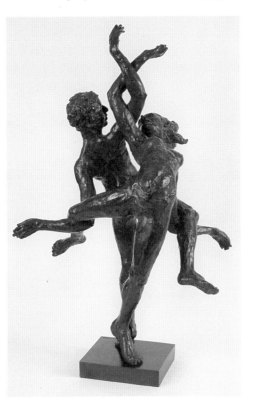

Impromptu, 1986
12 1/2 inches

Thunder and Lightning, 1989
33 inches

FOOTNOTES

CHAPTER 1

[1] *Lotus Eater* is related thematically to a series of contorted female figures from the same period. *Refuge* (1956), *Seated Figure with Outstretched Arms* (1956), *Eve* (1957), *Bather* (1958), *Apathy* (1959), *Compact Figure* (1959), *Figure on One Foot* (1959), *Frenzy* (1959), *Gordian Figure* (1959), *Allegorical Figure* (1960), *Bisymmetric Figure I* (1960), *Figure Holding Feet* (1960), *Figure on Hand and Foot, Holding Foot* (1960), *Harpy* (1960), *Small Figure Holding Feet* (1960), *Girl with Braids* (1961), and *Gordian Figure II* (1961) all share the motifs of fetal shape with twisted or intertwined limbs. One common feature in this series is the spreading of the legs to reveal the genitals in a frank statement of the life-giving potential of these brooding females.

[2] Lawrence Owen, in *Granlund: The Sculptor and His Work*, ed. Kathryn Christenson and Kelvin W. Miller (St. Peter: Gustavus Adolphus College, 1978) 137.

[3] Address on the dedication of *Apogee* in the William N. Wallace Memorial Court.

CHAPTER 2

[1] *The Anxiety of Influence: A Theory of Poetry* (Oxford: Oxford University Press, 1973) 30.
[2] Quoted in *Minneapolis Star* article by Marilynn J. Taylor, Dec. 23, 1978.
[3] For thirty-three years Professor of Art at Gustavus Adolphus College, and Granlund's first teacher.
[4] Swedish sculptor Carl Milles (1875-1955), born Vilhelm Carl Emil Anderson.

CHAPTER 3

[1] Quoted by Kathryn Christenson in "Things Visible and Invisible: the Sculpture of Paul Granlund," *The Cresset* xli.5 (March, 1978) 11-16, 14.

CHAPTER 4

[1] David Finn, *How to Look at Sculpture* (New York: Harry N. Abrams, Inc., 1989) 70.
[2] Christenson and Miller, 13.
[3] Gustavus Adolphus College Faculty Notes. I have deliberately misconstrued the poem, for which I apologize to its author. The entire text is as follows:

THE WINTER NYMPH SPEAKS

My three favorite things
are roses, colors and
my frost-free refrigerator.
That's why
I crawled, curled here
when frost began thickening
all along the state
calling down its sister, snow
to dance across the white mass.

Snow is humbug.
Snow is mirage, you know,
otherwise it could
be caught in crocks
and saved for cooling
next summer's butter.

They call me Winter Nymph
or Numph, numb gnome
in my glum, stone home
hunkering under
my nimbly-springing sisters—
those glib, silly siblings,
dancing in this snow
without their coats!

I am the eldest season—
I know when to take cover.
I will dance
when bronze liquifies,
when the axis of the earth
tilts like a sculptor's crucible,
when December
brings arbors of Midsummer
to the North Star State.

4 Dedication speech for *Sprites* at the University of Wisconsin at Eau Claire, Nov. 20, 1977, courtesy of President Larry Schnack of UWEC.

5 Quoted in Christenson and Miller, 171.

6 Christenson and Miller, 123. Is it significant that both of the comments on *Figure on One Leg* in the book come from theologians?

7 Quoted in Christenson and Miller, 101.

8 Dedication speech at the Tai Tam Campus of the Hong Kong International School, Nov. 2, 1988.

9 Quoted by Marilynn J. Taylor, *Minneapolis Star*, Dec. 23, 1978.

BIOGRAPHY

1 Quoted by Timothy Brady, "Man of Bronze," *Minnesota Monthly* 25.7 (July 1991) 25-27; 26.

BIOGRAPHY

Paul Granlund "gave me the confidence to believe I can be an artist." Thus Nick Legeros credits his teacher with the gift of the tools to lead a meaningful life, with the knowledge of what is important about sculpture and what is important about reality— and they are pretty much the same thing. The two things in particular Legeros says he can never shake off from his apprenticeship with Granlund are curiosity and the searching attitude of the child. "The greatest lesson he gave me was a sense of play."

It is apparent to any of the thousands of visitors who stroll through Granlund's studio each year that this artist is also a consummate teacher. Generous to a fault with his time, he is enthusiastic about engaging others in the issues he wonders about. In preparation for this book, I spent a week with Granlund, enrolling in a sculpture course he was teaching at the Grand Marais Art Colony. The very first thing he did when I arrived at his home in northern Minnesota was take me down to the shore of Lake Superior and teach me how to search for agates. To find an agate, you must crawl around on the ground so that your eye can catch the glint of the sun as the agate refracts it. This was my first sculpture lesson, and it sums up the kind of playful wonder that makes Granlund as great a teacher as he is a sculptor.

The human qualities that surface in Granlund's bronzes flow from the contradictory nature of his character. First, Paul Granlund has an omnivorous but critical mind. His intellectual interests range through philosophy, astronomy, the arts, and geology. Yet he is quick to challenge both ill-conceived ideas and theories that have overstayed their usefulness. Secondly, he has an omnivorous but critical heart. He is gregarious, witty, and generous, but is genuinely puzzled and hurt at the sight of people's unkindnesses to one another. Thirdly, Granlund has an omnivorous but critical soul. His spiritual and aesthetic insights are as profound as any theologian's and as ecumenical as any anthropologist's. Yet he has never been satisfied with received wisdom, continually probing for more authentic interpretations of human experience.

Paul Theodore Granlund was born October 6, 1925, to Naomi and Clarence O. Granlund, a legendary Augustana Synod Lutheran pastor of the pietist tradition. After graduation from Central High School in Minneapolis, Granlund served in the Army Air Corps in the Pacific theater. At the end of World War II, he alternated his time between the study of philosophy and art (at Gustavus Adolphus College and the University of Minnesota), and the study of life (in New England logging camps and steel mills).

By the time he graduated from Gustavus in 1952, he was married to Edna Spaeth. It was a marriage born of laughter, as each thought the other the most amusing person they had met. The laughter is still there: Paul of Edna: ". . .and always the humor—fresh, irreverent humor." Case in point: Edna of Paul: "I thought he was funny. Not many others in my circle did."[1] That humor has survived and it enabled the Granlunds to survive such adventures as three years of hand-washing the toddlers' diapers in nineteen-fifties Italy, rearing four children (three of them *boys*), and the vicissitudes of forty years of thunder and lightning between cynic and artist, idealist and professional nurse.

Granlund's graduate work was done at the University of Minnesota and at Cranbrook Academy, where he was awarded the M.F.A. in 1954. He studied in Florence on a Fulbright in 1954-55 and at the American Academy in Rome as a Guggenheim Fellow from 1957 to 1959. Although he has taught for short periods at several universities, including Cranbrook and The University of California at Berkeley, most of his professional career has been divided between the Minneapolis College of Art and Design and Gustavus Adolphus College. At the former, he was head of the sculpture department for fourteen years, and at Gustavus he has been sculptor-in-residence since 1971. He has received sixteen awards for his sculpture (including two honorary doctorates) and exhibited in more than seventy shows in galleries and museums throughout the country. His nearly six hundred bronzes appear in public spaces as far away as Paris and Hong Kong and in collections throughout the United States.

CASTING BRONZE

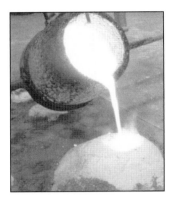

"Playing with the history and myth of casting fascinates me." Thus Paul Granlund expresses the mystique of the *cire perdue* (lost wax) process of bronze casting, whose venerable history may go back as much as three thousand years. Today the method, although more sophisticated, is essentially the same as in antiquity. Granlund is unique among sculptors in that he insists on casting his own work, rather than sending it to a foundry. The owner of a Granlund sculpture has the satisfaction of knowing that the creator's hand was present from the beginning.

There are five stages in the process from the artist's concept to finished bronze. "Sculpture is just a matter of lumps and holes, " Granlund will say as he molds his sculpture out of clay or microcrystalline wax, gouging out holes for eye sockets or adding lumps for eyeballs. This is the first step, the actual creation of the sculpture's form as it will finally appear in bronze weeks or months later. So the first stage is also the last.

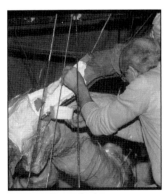

Coating clay with plaster

Next, Granlund paints the wax or clay model with plaster. Then he builds up a thick coat of plaster with a spatula, completely encasing the model in a mantle, which is segmented to facilitate being taken apart— a technique Granlund learned in Rome. He describes these "piece molds" as a box with a glove fit. In the third stage, Granlund removes the piece molds from the first model and immerses them in water to prevent adhesion of wax. Then he reassembles the plaster negative molds, leaving a hole for pouring (and later emptying) liquid wax. Repeating the process creates a hollow, wax version of the original sculpture, 5/32 of an inch thick. Granlund then removes the molds and touches up the hollow wax sculpture to erase seams and flaws. Next he connects the different parts of the sculpture with wax strips, creating a circulatory system of veins and arteries so that the molten bronze will flow evenly throughout the piece. The channels near the top act as vents for air to escape as the bronze flows in.

System of veins and arteries

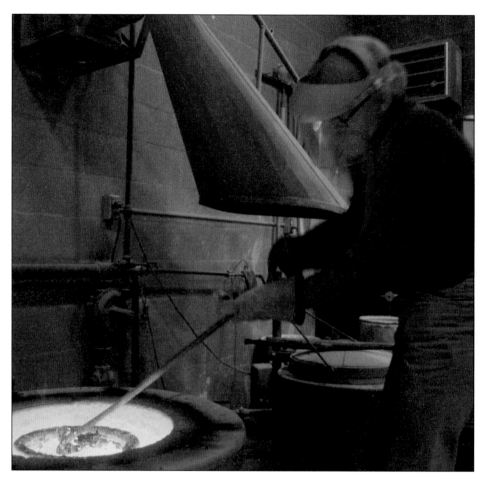

Bronze is melted to 1975 degrees Fahrenheit

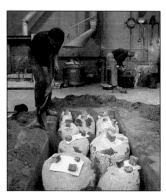

Molds are positioned for firing
in kiln

Hollow molds are buried in
sand pit

The fourth step involves another negative mold, created out of plaster, brick dust, and silica flour. Once again the wax sculpture is covered with a plaster mantle, but this time the plaster mixture is also poured into the hollow core of the wax model, to be connected to the mantle with metal rods or nails. The entire piece is then fired in a kiln at 1000-1200 degrees Fahrenheit for twenty-four to thirty hours until all the wax is burned off (thus the name of the "lost wax" process). The mold, composed of earth substances that combine into a refractory material, can withstand heat.

In the final stage, Granlund and his assistants bury the hollow plaster mold in a pit of sand in his studio, to buttress it and protect it from splitting. In Granlund's words, "What we have is a clearly defined sculptural hole in the earth." Now bronze (an alloy of copper and tin with traces of zinc, antimony, iron, and silicon) is melted to 1975 degrees Fahrenheit. Granlund and an assistant use a giant tongs and a hoist to lift a silicon carbide crucible, gleaming like the sun, from its furnace. With arms outstretched on the shank that controls the radiant cauldron of bronze, Granlund resembles the mythological Phaethon driving the chariot of the sun. Pouring bronze, Granlund says, is like the experience of flying: "I still get a few more heartbeats per

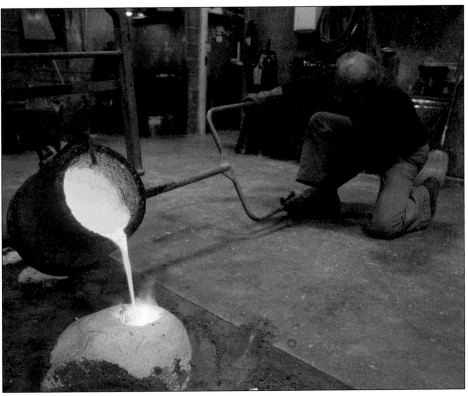
Pouring bronze

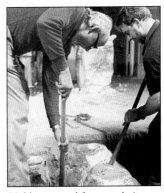
Molds extracted from sand pit

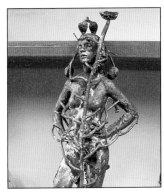
Bronze figure with skeleton of gates and vents

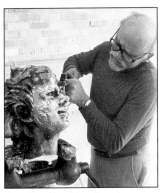
Grinding blemishes from bronze sculpture

minute each time it's done." The hollow impression of the sculptor's creation is impregnated with the flow of burning elemental energy. Molten bronze pours until every corner of the mold is filled and the golden liquid surges to the top and crests with surface tension.

After cooling, a new Granlund sculpture, or part of one, comes from the plaster womb of mother sand. Watching this happen is like being at the sixth day of Creation. The bronze is washed, and its external skeleton of gates and vents is removed. If it is a larger sculpture, its parts are welded together. Blemishes are ground and sanded away and holes are welded shut. The finished sculpture is treated with a light chemical wash, such as ferric nitrate, to begin acquiring its patina. The energies of the artist's spirit have transformed Earth's raw materials, clay (or wax) and bronze, in to an object that will store and communicate those energies forever.

CATALOGUE

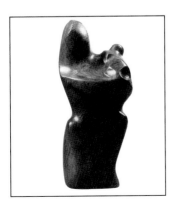

1. *Father and Son*, 1950
 30 inches, lead relief

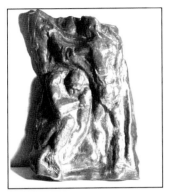

2. *Kite Form*, 1950
 13 inches, stainless steel

3. *Kneeling Madonna*, 1950
 14 inches, wood

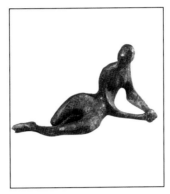

4. *Reclining Figure*, 1950
 4 inches long, lead

5. *Torso*, 1950
 14 inches, wood

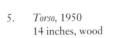

6. *Wailing Wall*, 1950
 12 inches, lead

7. *Adolescent*, 1951
 8 inches

8. *Ascetic*, 1951
 3 inches

9. *Baby*, 1951
 2 inches

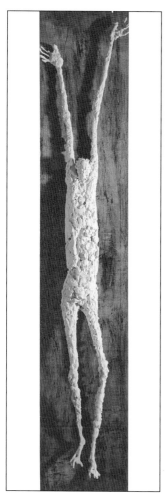

10. *Crucifixion*, 1951
 48 inches, plaster

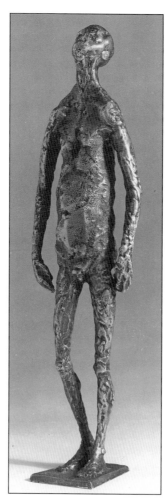

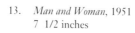

12. *Man*, 1951
 11 inches

13. *Man and Woman*, 1951
 7 1/2 inches

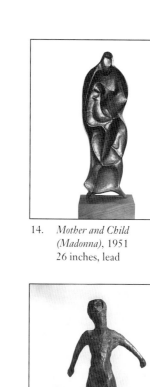

14. *Mother and Child*
 (Madonna), 1951
 26 inches, lead

15. *Pathetique*, 1951
 2 1/2 inches

16. *Seated Figure*, 1951
 12 inches, stone

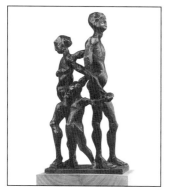

11. *Family*, 1951
 4 1/2 inches

17. *Senile*, 1951
 8 inches

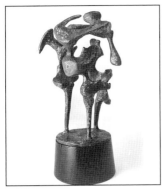

18. *Terror*, 1951
 11 inches

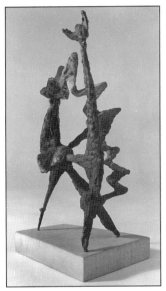

19. *Abstract*, 1952
 10 inches

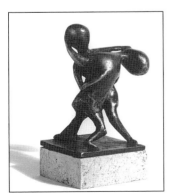

20. *Aggression*, 1952
 3 inches

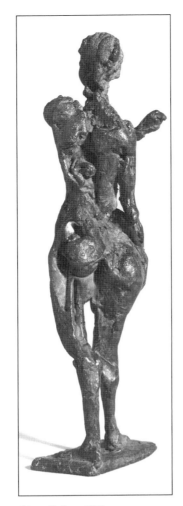

21. *Defiant*, 1952
 8 inches

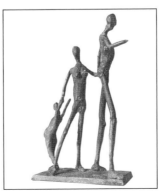

22. *Family*, 1952
 4 inches

23. *Figure*, 1952
 11 inches, copper

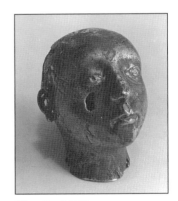

24. *Head*, 1952
 2 inches

25. *Janus*, 1952
 11 x 9 inches, copper

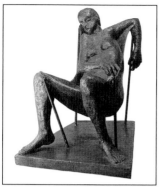

26. *Lethargy*, 1952
30 inches, plaster

30. *Prodigy*, 1952
2 inches

33. *Sparrow*, 1952
2 inches

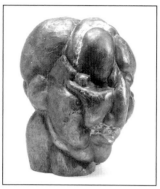

27. *Lobotomy*, 1952
15 inches, plaster

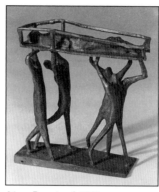

31. *Recessional*, 1952
7 inches

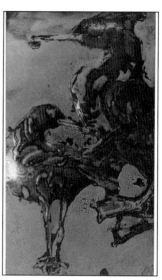

34. *Two Birds*, 1952
9 inches, enameled copper

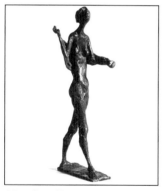

28. *Lyric Figure*, 1952
7 inches

32. *Repose*, 1952
8 x 11 inches, copper;
The Minneapolis Institute
of Arts, Minneapolis, MN

29. *Poet*, 1952
14 1/2 inches, plaster

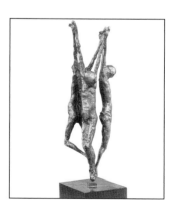

35. *Crucifixion*, 1953
8 inches

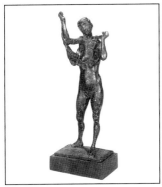

36. *Figure with Drape*, 1953
 7 inches

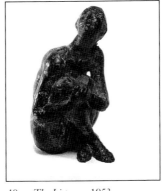

40. *The Listener*, 1953
 3 inches

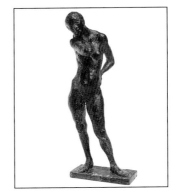

43. *Standing Figure*, 1953
 12 inches

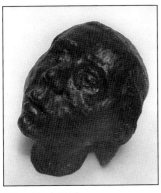

37. *Head*, 1953
 9 inches, wax

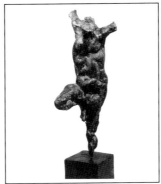

41. *Malefactor*, 1953
 18 inches

42. *Nike*, 1953
 6 inches

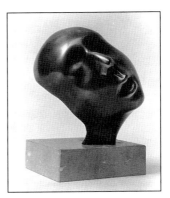

44. *Trance*, 1953
 4 inches

45. *Family*, 1954
 11 inches

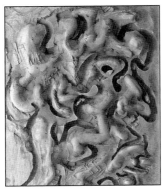

38. *Head*, 1953
 12 inches, plaster relief

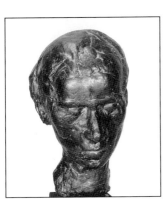

39. *Head of Girl*, 1953
 12 inches

46. *Fetus Relief*, 1954
 4 1/2 x 3 inches,
 pewter; also in bronze

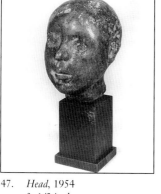

47. *Head*, 1954
3 1/2 inches

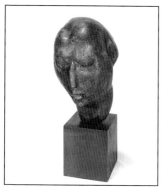

48. *Head*, 1954
11 inches

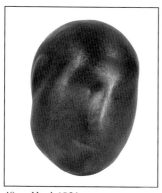

49. *Head*, 1954
9 inches, copper;
Cranbrook Museum,
Bloomfield Hills, MI

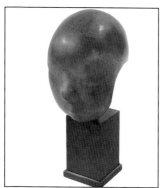

50. *Head of Child*, 1954
7 inches, copper

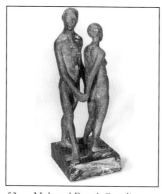

51. *Horizontal Figure*, 1954
5 inches

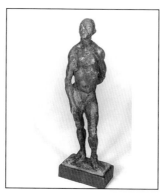

52. *Male and Female Standing
Figures*, 1954
11 inches

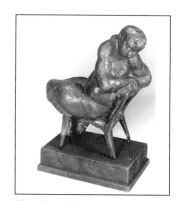

53. *Male Figure*, 1954
10 inches

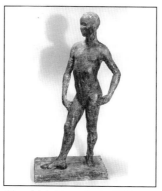

54. *Male Figure Study*, 1954
26 inches, plaster

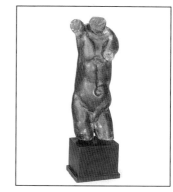

55. *Male Torso*, 1954
13 inches

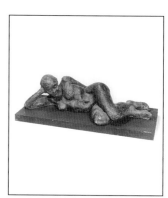

56. *Reclining Figure*, 1954
28 inches long, plaster

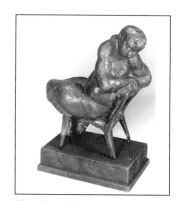

57. *Seated Figure*, 1954
6 inches

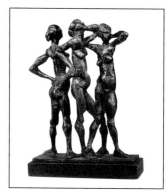

58. *Vanities*, 1954
6 inches

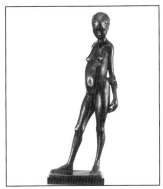

59. *Adolescent*, 1955
 19 inches

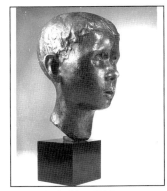

63. *Head of Boy*, 1955
 9 inches

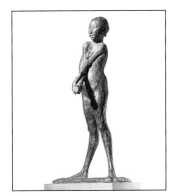

67. *Reticence*, 1955
 13 inches

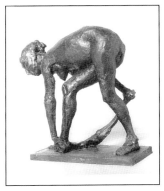

60. *Bather*, 1955
 6 inches

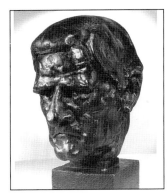

64. *Head of Old Man*, 1955
 11 inches, plaster

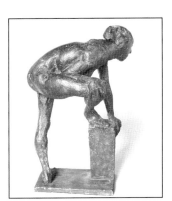

68. *Supported Figure*, 1955
 12 inches

69. *Draped Figure I*, 1956
 11 inches, terra cotta

70. *Draped Figure II*, 1956
 6 inches

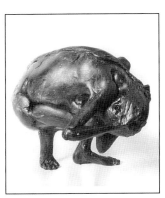

61. *Defense Mechanism*, 1955
 10 1/4 inches

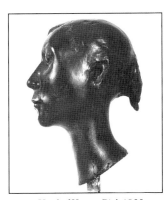

65. *Head of Young Girl*, 1955
 11 inches

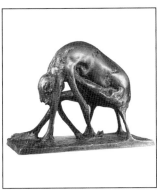

62. *Dissolution*, 1955
 8 inches

66. *Leaning Figure*, 1955
 12 inches;
 Walker Art Center,
 Minneapolis, MN

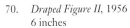

71. *Figure in the Garden*, 1956
 27 inches, plaster

72. *Figure on One Foot*, 1956
 17 1/2 inches;
 University of Minnesota Art
 Gallery, Minneapolis, MN

73. *Figures and Shadows*, 1956
 11 inches

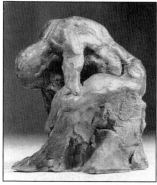

74. *Man Sleeping*, 1956
 6 inches,
 terra cotta; also in bronze

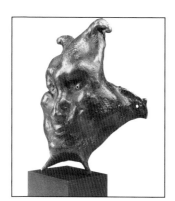

75. *Mask*, 1956
 10 inches

76. *Mother and Boy*, 1956
 6 inches

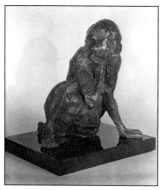

77. *Reclusion*, 1956
 7 x 14 1/2 inches

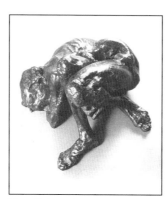

78. *Refuge*, 1956
 9 1/2 x 13 1/2 inches

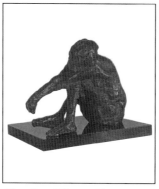

79. *Seated Figure with
 Outstretched Arms*, 1956
 7 1/2 inches

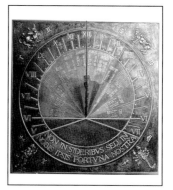

80. *Sundial*, 1956
 22 x 22 inches

80A. *Seated Figure*, 1956
 7 1/2 inches

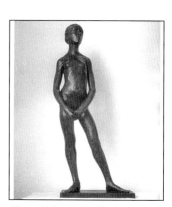

81. *Adolescent*, 1957
 33 1/2 inches;
 The Minneapolis Institute
 of Arts, Minneapolis, MN

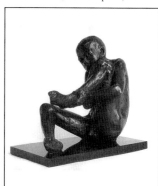

82. *Boy with Foot*, 1957
 10 1/2 inches

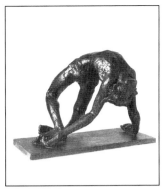

83. *Crucifixion*, 1957
16 1/4 inches,
bronze and wood

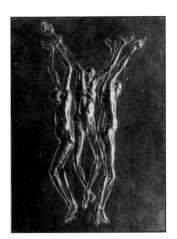

84. *Crucifixion Relief*, 1957
17 x 11 inches

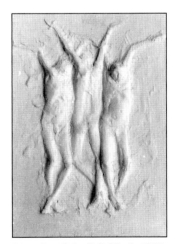

85. *Crucifixion Relief Study*, 1957
17 x 11 inches, plaster

86. *Deposition Study*, 1957
11 inches, plaster

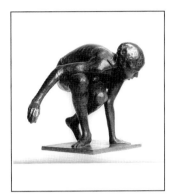

87. *Eve*, 1957
18 inches;
Augustana College,
Sioux Falls, SD

88. *Figure on Hand and Knee*, 1957
3 inches

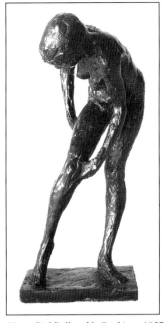

89. *Girl Pulling Up Stockings*, 1957
14 inches, plaster

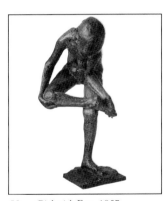

90. *Girl with Foot*, 1957
18 inches

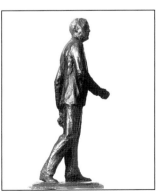

91. *Governor Olson*
Competition Model, 1957
18 inches, plaster

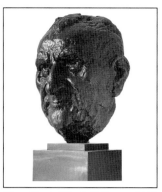

92. *Head of Dr. L.B. Benson*, 1957
 12 inches;
 Bethesda Lutheran Medical
 Center, St. Paul, MN

93. *Head of Young Boy*, 1957
 10 inches, terra cotta

94. *Head of Young Man*, 1957
 13 inches

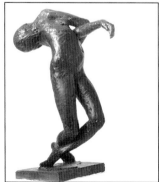

95. *Ophelia I*, 1957
 17 inches

96. *Reclining Figure with Arms
 Extended*, 1957
 4 inches

97. *Rising Figure*, 1957
 12 1/2 inches, plaster

98. *Seated Figure with Crossed
 Legs*, 1957
 13 inches, plaster

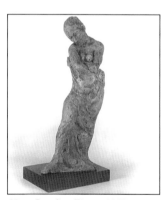

99. *Standing Figure*, 1957
 13 inches, terra cotta

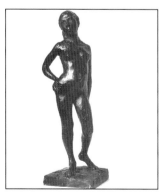

100. *Standing Figure with Hand
 on Hip*, 1957
 19 inches, plaster

101. *Trio*, 1957
 13 inches

102. *Trio Model*, 1957
 3 inches

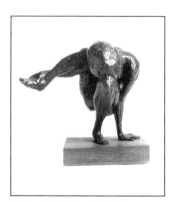

103. *Ambivalence I*, 1958
 8 1/4 inches

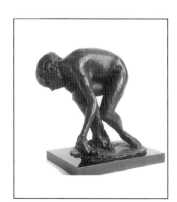

104. *Bather*, 1958
 8 inches

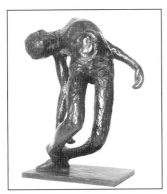

105. *Deposition I*, 1958
 13 inches

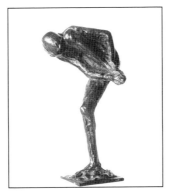

109. *Figure on One Foot*, 1958
 8 3/4 inches

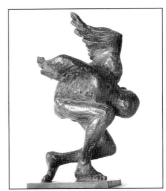

112. *Jacob and the Angel I*, 1958
 18 1/2 inches

110. *Figures and Shadows Relief*, 1958
 10 3/4 x 8 inches, copper

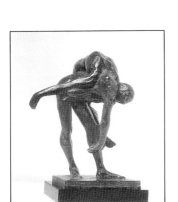

106. *Deposition II*, 1958
 8 1/4 inches

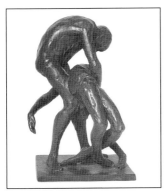

107. *Deposition III*, 1958
 7 1/4 inches

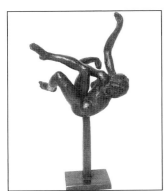

108. *Falling Figure*, 1958
 9 3/4 inches

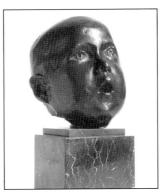

111. *Head of Gregory*, 1958
 7 inches

113. *Relief Studies*, 1958
 4 panels, 9 x 12 inches, plaster

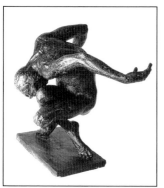

114. *Resurrection*, 1958
 17 3/4 inches;
 Lutheran Church of the
 Good Shepherd,
 Minneapolis, MN

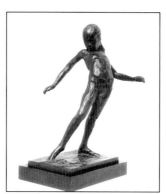

116. *Young Balanced Figure*, 1958
 8 1/2 inches

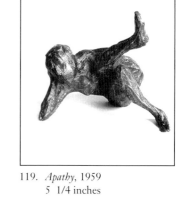

119. *Apathy*, 1959
 5 1/4 inches

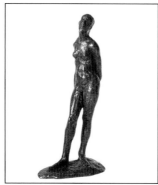

117. *Young Woman*, 1958
 8 inches

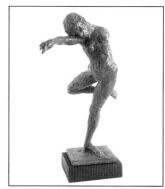

120. *Balanced Figure*, 1959
 11 inches;
 American Swedish Institute,
 Minneapolis, MN

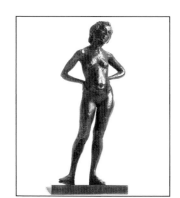

115. *Standing Figure*, 1958
 15 1/2 inches

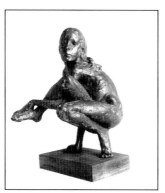

118. *Ambivalence II*, 1959
 15 1/4 inches

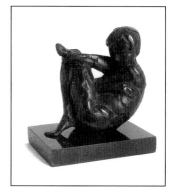

121. *Compact Figure*, 1959
 5 inches

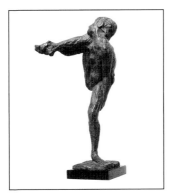

122. *Figure on One Foot*, 1959
13 inches

123. *Figure on One Leg*, 1959
9 3/4 inches

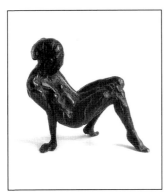

124. *Figure on Three
Points*, 1959
2 1/2 x 4 inches

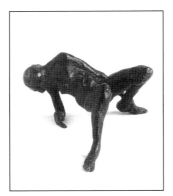

125. *Figure Resting on Elbow*, 1959
2 x 5 inches

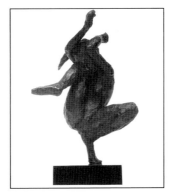

126. *Frenzy*, 1959
16 inches, plaster

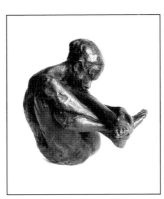

127. *Gordian Figure I*, 1959
13 3/4 inches

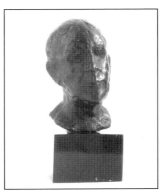

128. *Head of Man*, 1959
3 inches

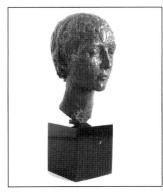

129. *Head of Young Girl*, 1959
11 inches

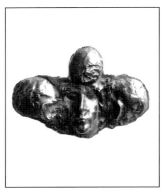

130. *Listener*, 1959
5 x 8 inches

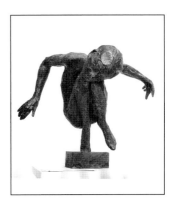

131. *Phoenix*, 1959
12 inches

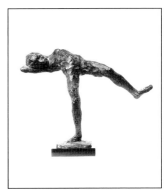

132. *Reclination*, 1959
9 1/2 inches

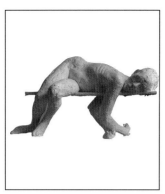

133. *Reclining Figure on Bench*, 1959
20 inches, plaster

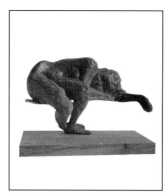

137. *Sleeper*, 1959
7 1/2 inches

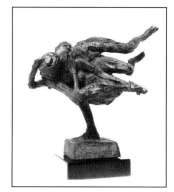

141. *Two Figures I*, 1959
5 1/2 inches

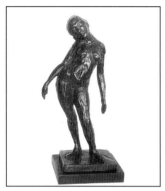

134. *Relaxed Figure*, 1959
8 3/4 inches

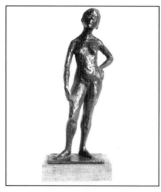

138. *Standing Figure*, 1959
10 3/4 inches

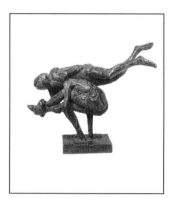

142. *Two Figures II*, 1959
5 3/4 inches

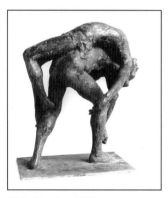

135. *Requiem*, 1959
25 1/2 inches

136. *Seated Figure Holding
Leg*, 1959
6 1/4 inches, terra cotta

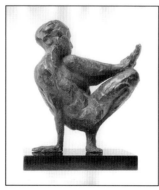

139. *Structured Figure*, 1959
6 3/4 inches

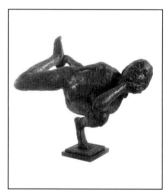

143. *Allegorical Figure*, 1960
18 1/2 inches

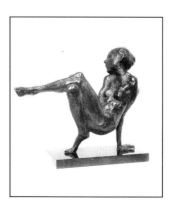

140. *Transfluent Figure*, 1959
11 inches

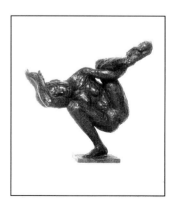

144. *Ambivalence III*, 1960
16 1/2 inches

145. *Birth*, 1960
 12 x 5 inches, bronze relief

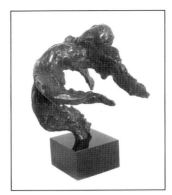

149. *Double Phoenix*, 1960
 10 inches

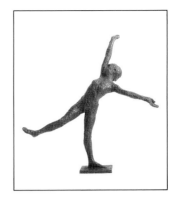

153. *Figure March '60*, 1960
 27 inches

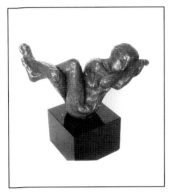

146. *Bisymmetric Figure I*, 1960
 6 inches

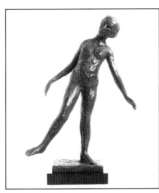

150. *Figure Balanced on One
 Foot*, 1960
 8 1/2 inches

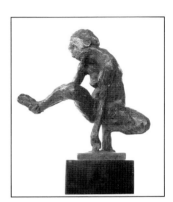

154. *Figure on Hand and Foot,
 Holding Foot*, 1960
 5 3/4 inches

155. *Figure on One Foot*, 1960
 19 inches

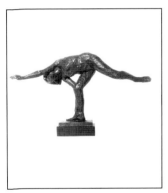

147. *Bisymmetric Figure II*, 1960
 9 inches

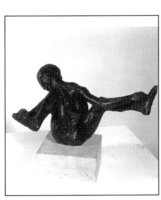

151. *Figure Holding Feet*, 1960
 4 x 7 1/2 inches

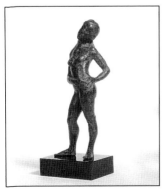

148. *Bonnie*, 1960
 11 1/4 inches

152. *Figure Holding Feet Winged*, 1960
 2 1/2 x 4 inches

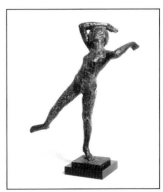

156. *Figure with Arms Raised*, 1960
 14 inches

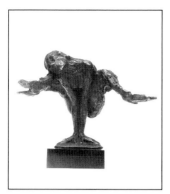

157. *Harpy*, 1960
5 x 7 inches

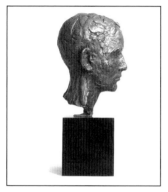

158. *Head of Young Man*, 1960
11 1/2 inches

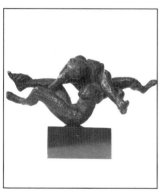

159. *Horizontal Lovers I*, 1960
5 x 13 inches

160. *Little Figure Balanced on Hands*, 1960
4 1/2 inches

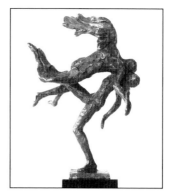

161. *Lovers with Arm and Leg Winged Model*, 1960
10 1/2 inches

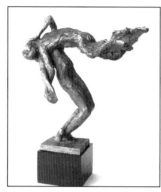

162. *Lovers with Legs Winged*, 1960
10 inches

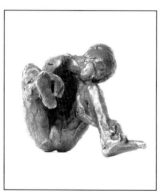

164. *Small Figure Holding Feet*, 1960
4 1/2 inches

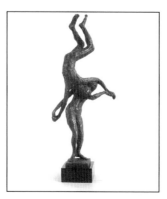

165. *Vertical Lovers*, 1960
17 inches

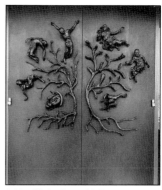

166. *Christ Door*, 1961
56 x 64 inches;
Christ Chapel,
Gustavus Adolphus College,
St. Peter, MN

167. *Fetus*, from *Christ Door*, 1961
10 1/4 inches

168. *Girl with Braids*, 1961
11 3/4 inches

169. *Gordian Figure II*, 1961
11 x 20 inches

170. *Horizontal Lovers II*, 1961
8 inches long

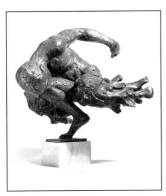

171. *Jacob and the Angel II*, 1961
22 inches;
Highland Park Shopping
Center, Chicago, IL; Mount
Olivet Lutheran Church,
Minneapolis, MN

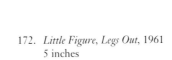

172. *Little Figure, Legs Out*, 1961
5 inches

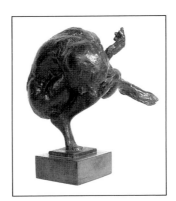

173. *Lotus Eater*, 1961
13 1/2 inches

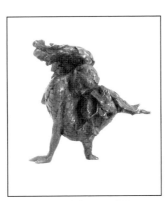

174. *Sleeping Phoenix*, 1961
10 inches

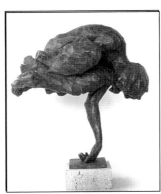

175. *Suspended Figure*, 1961
14 inches

176. *Crucifixion Model*, 1962
16 1/2 inches

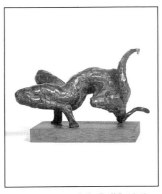

177. *Europa and the Bull I*, 1962
7 1/2 inches long

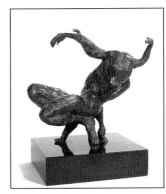

178. *Europa and the Bull II*, 1962
8 inches

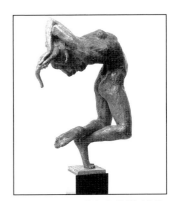

179. *Europa and the Bull III*, 1962
25 inches

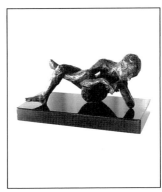

180. *Figure on Elbow and Heel*, 1962
3 1/2 inches

181. *Girl Resting on Hands*, 1962
5 3/4 inches long

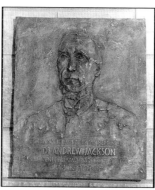

182. *Gustavus President
Dr. Andrew Jackson*, 1962
15 x 12 inches;
Gustavus Adolphus College,
St. Peter, MN

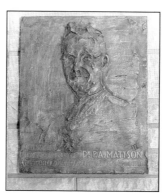

184. *Gustavus President
Dr. P.A. Mattson*, 1962
15 x 12 inches;
Gustavus Adolphus College,
St. Peter, MN

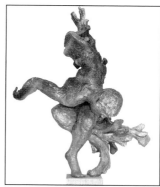

186. *Jacob and the Angel III*, 1962
63 inches;
Gustavus Adolphus College,
St. Peter, MN; North Shore
Congregation Israel,
Glencoe, IL

183. *Gustavus President
Dr. O.J. Johnson*, 1962
15 x 12 inches;
Gustavus Adolphus College,
St. Peter, MN

185. *Gustavus President
Dr. Erik Norelius*, 1962
15 x 12 inches;
Gustavus Adolphus College,
St. Peter, MN

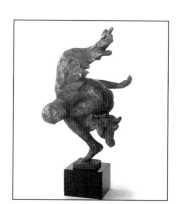

187. *Jacob and the Angel III
Model*, 1962
6 inches

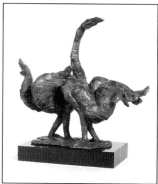

188. *Leda and the Swan*, 1962
10 1/4 inches

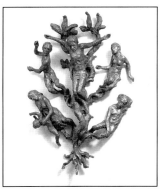

189. *New Testament Door*, 1962
40 x 27 inches;
Christ Chapel,
Gustavus Adolphus College,
St. Peter, MN

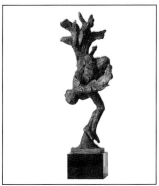

192. *Transfiguration*, 1962
12 inches

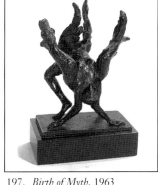

197. *Birth of Myth*, 1963
6 1/2 inches

198. *Children Model*, 1963
5 1/4 inches

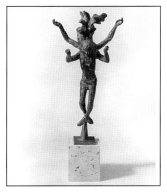

193. *At One Ment*, 1963
14 1/2 inches

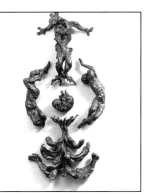

190. *Old Testament Door*, 1962
41 1/4 x 20 1/2 inches;
Christ Chapel,
Gustavus Adolphus College,
St. Peter, MN

191. *Sleeper*, 1962
8 inches

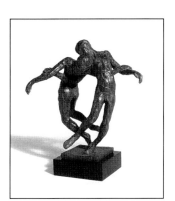

194. *Bacio I*, 1963
9 inches

195. *Bacio II*, 1963
11 1/2 inches

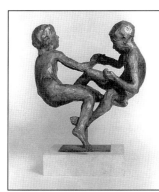

199. *Children*, 1963
22 inches

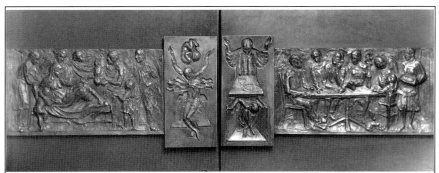

196. *Baptism/Lord's Supper Door*, 1963
18 x 72 inches;
Christ Chapel,
Gustavus Adolphus College,
St. Peter, MN

200. *Christ, Peter and Paul*, 1963
40 x 30 inches;
Mount Olivet Lutheran
Church, Minneapolis, MN

201. *Embrace*, 1963
6 inches

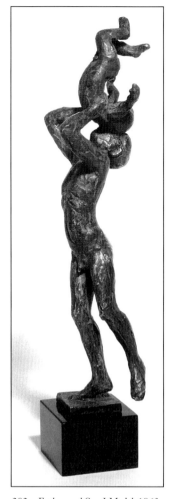

202. *Father and Son I Model*, 1963
14 inches

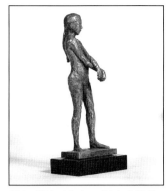

204. *Girl with Arms Linked*, 1963
8 1/2 inches

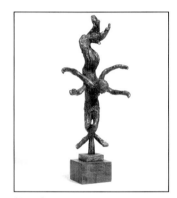

205. *Incarnation*, 1963
10 inches

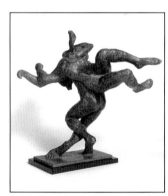

206. *Lovers Back to Back*, 1963
24 inches;
Sheldon Memorial Gallery,
University of Nebraska,
Lincoln, NE

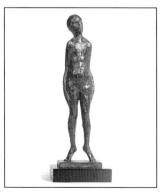

203. *Girl on Toes*, 1963
8 1/2 inches

207. *Man with Arms Raised*, 1963
9 inches

211. *Small Figure Exercising*, 1963
4 inches

215. *Crucifixion Model*, 1964
13 1/4 inches;
Lutheran Church of the Good
Shepherd, Minneapolis, MN

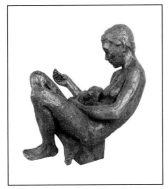

208. *Mother and Child*, 1963
19 inches

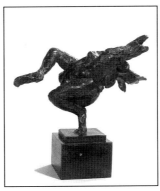

212. *Suigeneris*, 1963
6 1/2 inches

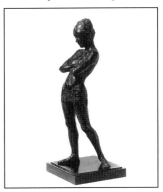

216. *Diane*, 1964
14 inches

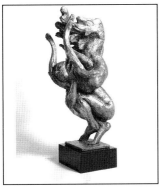

209. *Poet and the Muse*, 1963
20 inches;
Fergus Falls Public Library,
Fergus Falls, MN

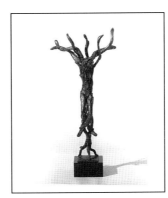

213. *Tree*, 1963
11 inches

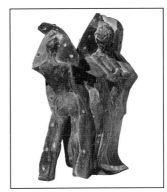

217. *Figure in Rotation*, 1964
15 inches

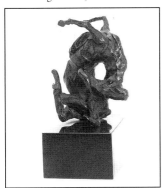

210. *Sacrificial Goat*, 1963
4 1/4 inches

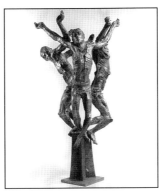

214. *Crucifixion*, 1964
60 inches;
Lutheran Church of the
Good Shepherd,
Minneapolis, MN;
Bethlehem Lutheran
Church, Mankato, MN

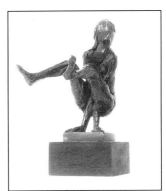

218. *Figure on Hands*, 1964
3 1/2 inches

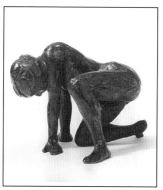

219. *Figure on Hands and Knee,* 1964
 5 1/4 inches

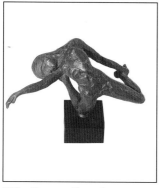

220. *Figure on Knee, Arm
 Extended,* 1964
 5 1/2 inches

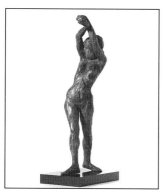

221. *Figure with Arms Linked,* 1964
 15 inches

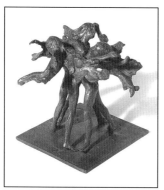

222. *Flower,* 1964
 9 1/2 inches

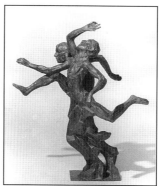

223. *Gemini,* 1964
 27 inches;
 St. Paul Academy,
 St. Paul, MN

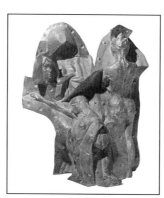

224. *Gemini Model,* 1964
 10 3/4 inches

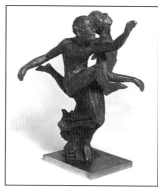

225. *Gothic Facade,* 1964
 14 1/2 inches

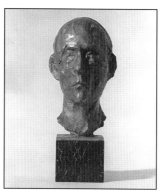

226. *Head of Young Man,* 1964
 16 inches

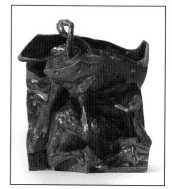

227. *Lament,* 1964
 12 inches

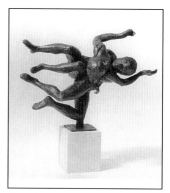

228. *Lovers on One Knee,* 1964
 10 inches

229. *Matrix I,* 1964
 9 inches

230. *Portrait Relief,* 1964
 17 x 22 inches

231. *Reclining Figure,* 1964
 13 inches long

232. *Reclining Figure in Mold Relief*, 1964
15 inches

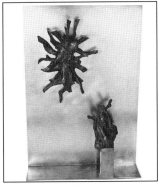

236. *Damascus Illumination Model*, 1965
17 inches

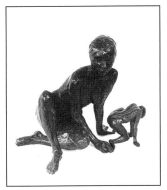

241. *Figure with Figure*, 1965
16 1/2 inches

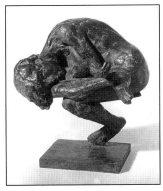

233. *Sleeper*, 1964
15 inches;
University of Wisconsin at
Eau Claire, Eau Claire, WI

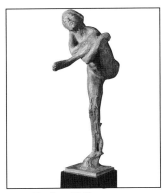

237. *Daphne*, 1965
13 inches

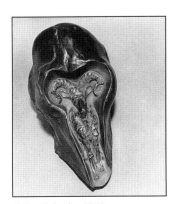

242. *Golgotha*, 1965
9 inches

243. *Head of Chris Bell*, 1965
12 inches

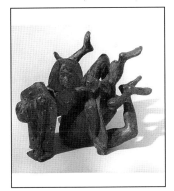

234. *Sphinx*, 1964
7 1/2 inches

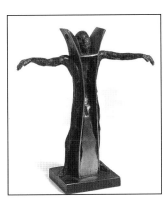

238. *Emerging Figure*, 1965
10 inches

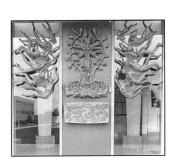

244. *Hope Door*, 1965
5 feet 5 1/4 inches x 9 feet;
Christ Chapel,
Gustavus Adolphus College,
St. Peter, MN

235. *Cassandra*, 1965
19 1/4 inches;
The Minneapolis Institute
of Arts, Minneapolis, MN

239. *Eulogy*, 1965
28 1/4 inches

240. *Figure Against a Wall*, 1965
9 inches

245. *Invisible I*, 1965
6 1/2 inches

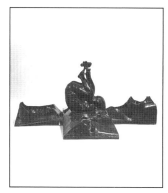

249. *Matrix II*, 1965
8 1/2 inches

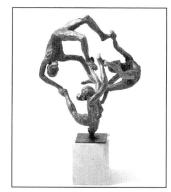

253. *Sprites Study*, 1965
6 inches

246. *Kneeling Figure*, 1965
10 inches

247. *Leaning Figure*, 1965
15 1/2 inches

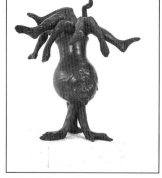

250. *Medusa*, 1965
15 inches

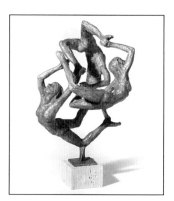

254. *Sprites Model*, 1965
17 inches

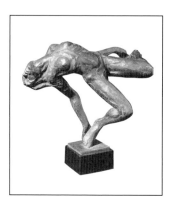

251. *Ophelia II*, 1965
14 inches

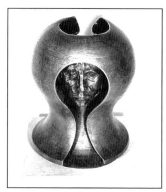

255. *Tiny Alice I*, 1965
12 inches

248. *Luna*, 1965
24 inches

252. *Seated Figure*, 1965
8 inches

256. *Colts*, 1966
10 inches

257. *Father Flanagan Portrait*, 1966
26 inches, plaster

261. *Night*, 1966
18 1/2 inches

265. *Vortex*, 1966
26 inches

258. *Figures in Contour*, 1966
21 inches

262. *Profile*, 1966
14 inches

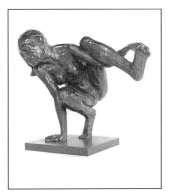

266. *Ambivalence IV*, 1967
15 inches

267. *Boys
Washington Model I*, 1967
6 inches

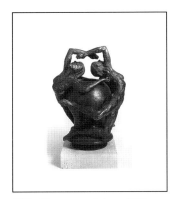

259. *Figures on a Sphere*, 1966
15 inches

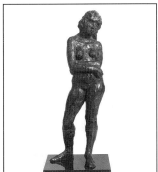

263. *Standing Figure*, 1966
20 inches

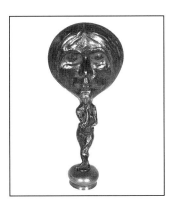

260. *Mirror*, 1966
16 1/2 inches

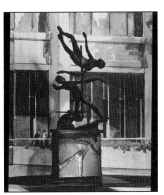

264. *United States Courthouse
Model*, 1966
13 inches, wax

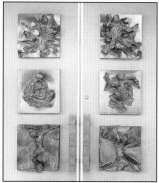

268. *Credo Doors*, left, 1967
6 panels, 18 x 18 inches;
Lutheran Church of the
Good Shepherd,
Minneapolis, MN

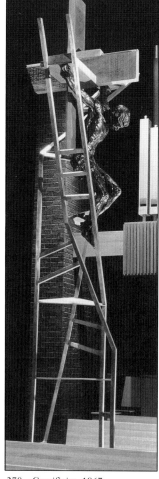

270. *Crucifixion*, 1967
12 feet;
Luther Northwestern
Theological Seminary,
St. Paul, MN

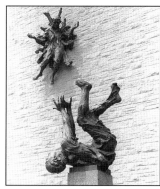

272. *Damascus Illumination*, 1967
Christ, 10 feet 6 inches;
Paul, 5 feet 5 inches;
St. Paul's Lutheran Church,
La Crosse, WI

273. *Father Damien*, 1967
26 inches;
Minneapolis League of
Catholic Women,
Minneapolis, MN

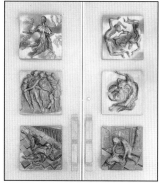

269. *Credo Doors*, right, 1967
6 panels, 18 x 18 inches;
Lutheran Church of the
Good Shepherd,
Minneapolis, MN

274. *Father Flanagan Figure*, 1967
24 inches

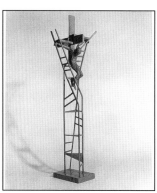

271. *Crucifixion Model*, 1967
28 inches

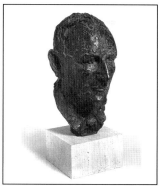

275. *Head of My Father*, 1967
14 1/2 inches

276. *Josiah*, from *Old Testament
Frieze*, 1967
14 inches

277. *Old Testament Frieze*,
left detail, 1967
17 feet;
Christ Chapel,
Gustavus Adolphus College,
St. Peter, MN

278. *Old Testament Frieze*,
left center detail

279. *Old Testament Frieze*,
center detail

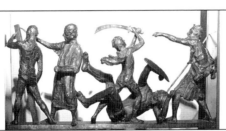

280. *Old Testament Frieze*,
right center detail

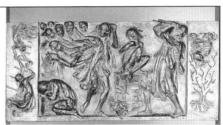

281. *Old Testament Frieze*,
right detail

281. *Old Testament Frieze*,
right detail

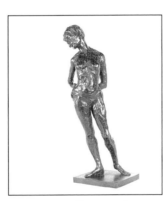

284. *Standing Figure*, 1967
18 inches

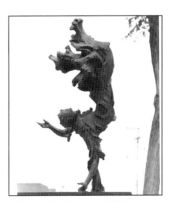

286. *Bethesda Angel*, 1968
66 inches;
Bethesda Lutheran Medical
Center, St. Paul, MN

287. *Bethesda Angel Model I*, 1968
6 inches

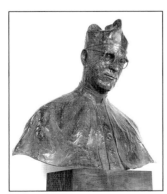

282. *Father Flanagan Portrait*, 1967
34 inches;
Lincoln Hall of Fame, Lincoln, NE

283. *Small Standing Figure*, 1967
6 3/4 inches

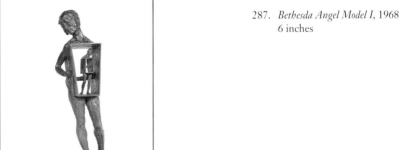

285. *Tiny Alice II*, 1967
18 inches

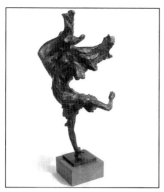

288. *Bethesda Angel Model II*, 1968
26 inches

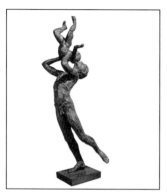

289. *Father and Son I*, 1968
30 inches

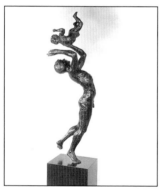

290. *Father and Son II*, 1968
52 inches

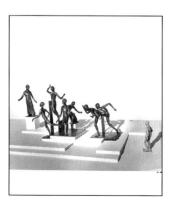

291. *Father Flanagan
Washington Model I*, 1968
10 inches;
Boys Town, NE

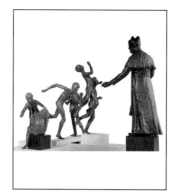

292. *Father Flanagan
Washington Model II*, 1968
24 inches;
Boys Town, NE

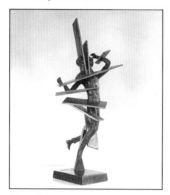

293. *Figure in Planes*, 1968
13 1/2 inches

294. *Ambivalence IV Head*, 1968
4 1/2 inches

295. *Hurdlers
Washington Model I*, 1968
8 inches

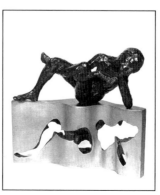

296. *Invisible II*, 1968
7 inches

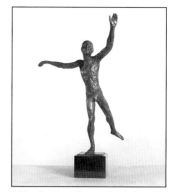

297. *Striding Figure*, from *Son of
Man Be Free*, 1968
12 1/2 inches

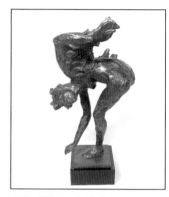

298. *TV Angel*, 1968
15 inches

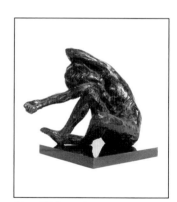

299. *Waking Woman*, 1968
9 1/4 inches;
Carleton College,
Northfield, MN

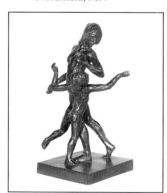

300. *Adolescent and Child*, 1969
8 inches

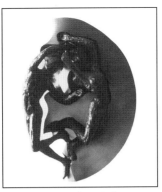

301. *Adore Knocker*, 1969
13 1/2 inches

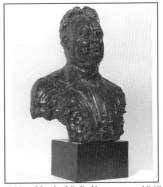

303. *Head of O.P. Kretzmann*, 1969
16 1/2 inches;
Valparaiso University,
Valparaiso, IN

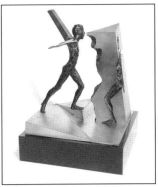

307. *Man-Nam Model II*, 1969
11 inches; Veterans Service
Building, Capitol Complex,
St. Paul, MN

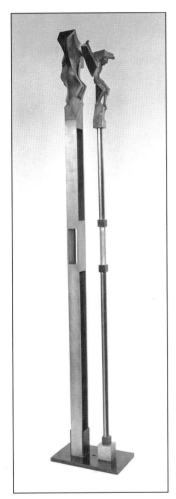

302. *Crucifixion*, 1969
processional cross, 7 feet;
Mary Mother of the
Church, Burnsville, MN;
Dana College, Blair, NE

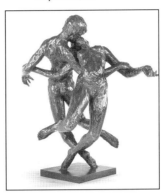

304. *Lovers*, 1969
39 inches

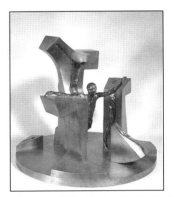

308. *Son of Man Be Free Model*, 1969
19 inches

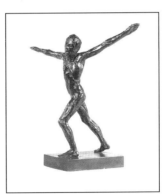

305. *Man*
Man-Nam Model II, 1969
9 1/2 inches

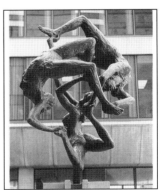

309. *Sprites*, 1969
8 feet;
Metropolitan Mount Sinai
Medical Center,
Minneapolis, MN

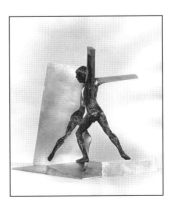

306. *Man-Nam Model I*, 1969
10 inches

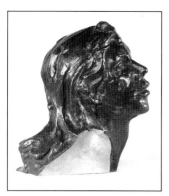

310. *Sprites Head*, 1969
16 inches

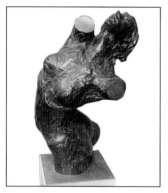

311. *Sprites Torso*, 1969
51 inches

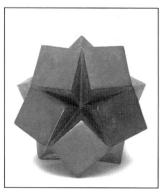

312. *Balanced Figure*, 1970
5 1/2 inches

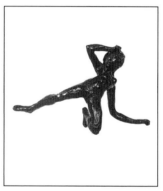

313. *Cube Star Model*, 1970
2 1/4 x 4 inches

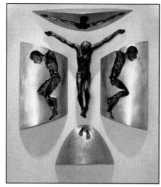

314. *Crucifixion*, 1970
42 x 36 inches;
Mount Olivet Lutheran
Church, Minneapolis, MN

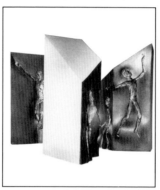

315. *Father Flanagan
Washington Model III*, 1970
15 inches;
Boys Town, NE

316. *Figure with Arm Extended*, 1970
33 1/2 inches

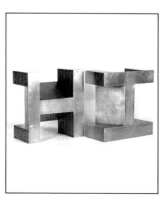

317. *H-I*, 1970
10 inches

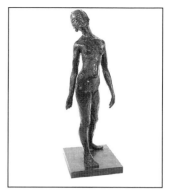

318. *Kathy*, 1970
33 1/2 inches

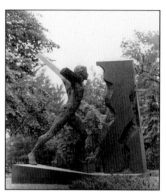

319. *Man-Nam*, 1970
8 feet;
Governor's Residence,
St. Paul, MN

320. *Man-Nam Poem*, 1970
6 x 6 1/2 inches;
Folke Bernadotte Memorial
Library, Gustavus Adolphus
College, St. Peter, MN

321. *One-Two*, 1970
8 3/4 inches

322. *Ritual of the Cube*, 1970
7 inches

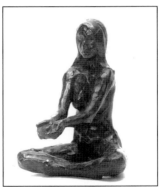

322A. *Ritual of the Cube
Figure*, 1970
6 1/2 inches

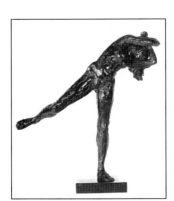

323. *Abandoned Figure*, 1971
22 inches

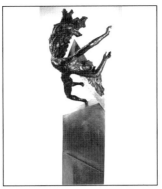

324. *Ascendance*, 1971
6 feet 6 inches;
La Crosse Public Library,
La Crosse, WI

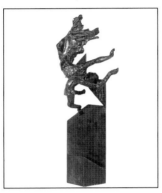

325. *Ascendance Model*, 1971
12 inches;
La Crosse Public Library,
La Crosse, WI

326. *BC AD Model*, 1971
3-inch cube

327. *B to A+*, 1971
11 1/2 inches

328. *Cube Star*, 1971
5 x 9 1/4 inches

329. *Double S Model*, 1971
2 inches

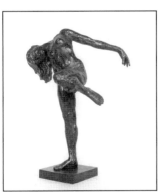

330. *Figure Holding Leg*, 1971
27 1/2 inches

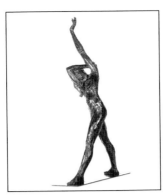

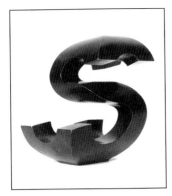

331. *Kneeling Figure*, 1971
4 inches

332. *The Time Being, Male Figure*, 1971
30 inches

335. *Reaching Figure*, 1971
39 inches

339. *Double S*, 1972
9 1/2 inches

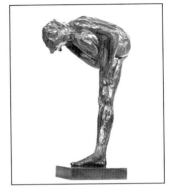

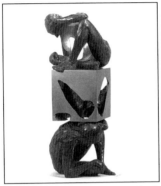

336. *Seed*, 1971
15 1/2 inches

340. *Figure Cubed and Sphered*, 1972
32 1/2 inches

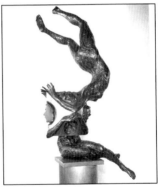

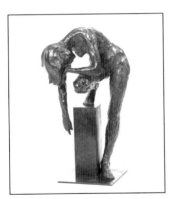

333. *Masks of the Muses*, 1971
6 feet;
Gustavus Adolphus College,
St. Peter, MN

337. *Son of Man Be Free*, 1971
10 feet;
Concordia Teachers
College, Seward, NE

341. *Figure on Pedestal*, 1972
14 inches

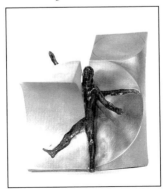

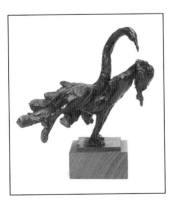

334. *Masks of the Muses Model*, 1971
19 inches

338. *The Time Being Model I*, 1971
5 inches;
Federal Reserve Bank,
Minneapolis, MN

342. *Leda and the Swan*, 1972
6 3/4 inches

343. *One and One Half*, 1972
8 3/4 inches

344. *Small Kneeling Figure*, 1972
3 1/2 inches

345. *Standing Figure, Arms Back of Head*, 1972
7 inches

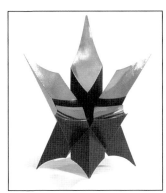

346. *Starburst*, 1972
18 1/2 inches

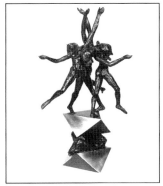

347. *Winter and Summer Nymphs Model*, 1972
14 3/4 inches;
H.R.H. Princess Christina of Sweden

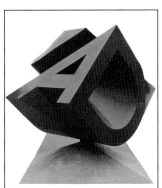

348. *BC AD*, 1973
48-inch cube;
Gustavus Adolphus College,
St. Peter, MN

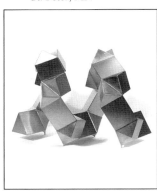

349. *Continuum Model*, 1973
21 x 34 1/2 inches, stainless steel

350. *Cross*, 1973
16 inches;
St. John's University,
Collegeville, MN

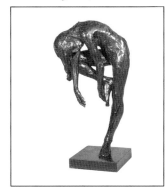

351. *Figure on One Leg*, 1973
18 inches

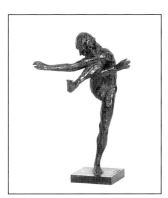

352. *Male Criss-Cross*, 1973
10 3/4 inches

353. *One Two Three Four Five*, 1973
10 inches;
American National Bank,
St. Paul, MN

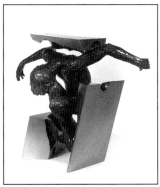

354. *Resurrection II*, 1973
 18 inches;
 St. Mark's Cathedral,
 Minneapolis, MN;
 Lake Harriet United
 Methodist Church,
 Minneapolis, MN;

355. *Sprites*, 1973
 model for award, 8 1/4 inches;
 Metropolitan Mount Sinai
 Medical Center,
 Minneapolis, MN

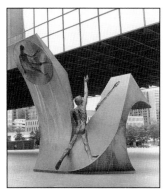

356. *The Time Being*, 1973
 12 feet, bronze and stainless steel;
 Federal Reserve Bank,
 Minneapolis, MN

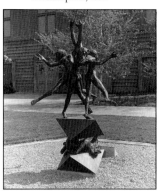

357. *Winter and Summer
 Nymphs*, 1973
 6 feet;
 Minnesota Landscape
 Arboretum,
 Chanhassen, MN

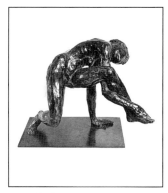

360. *Bridge*, 1974
 14 1/2 inches

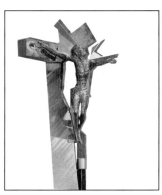

361. *Chancel Crucifixion*, 1974
 processional cross, 7 feet;
 First Lutheran Church,
 St. Peter, MN

362. *Crack the Whip*, 1974
 7 inches

363. *Cross*, 1974
 25 inches

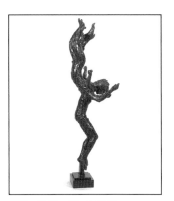

358. *At One Ment*, 1974
 36 inches

359. *Bell*, 1974
 6 1/2 inches

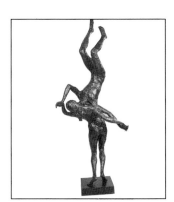

364. *Earth and Sky*, 1974
 7 feet

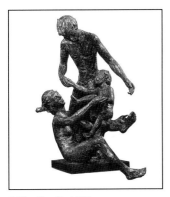

365. *Family*, 1974
44 inches;
Norwest Banks Art
Collection, Minneapolis, MN

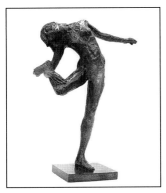

366. *Family Model*, 1974
8 inches

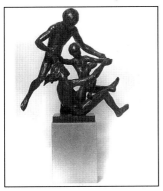

367. *Figure Holding Leg*, 1974
23 inches

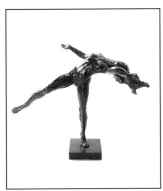

368. *Figure October 5*, 1974
12 inches

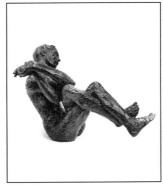

369. *Gordian Figure III*, 1974
15 3/4 inches

370. *Leaper*, 1974
12 1/4 inches

371. *Portrait of Dale Shephard*, 1974
18 inches;
Campus Club, University of
Minnesota, Minneapolis, MN

372. *Sonata Model*, 1974
21 1/2 inches

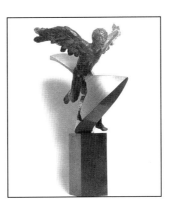

373. *Spirit of Courage Model I*, 1974
15 1/2 inches

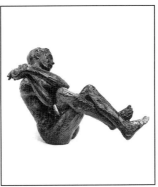

374. *Sunrise*, 1974
24 1/2 x 29 inches

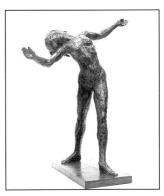

375. *Sunrise Figure*, 1974
24 1/2 inches

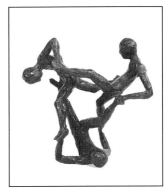

376. *Three Boys*, 1974
5 3/4 inches

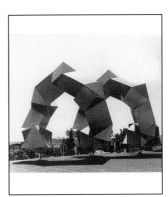

377. *Continuum*, 1975
14 x 24 feet, stainless steel;
Five Flags Plaza,
Dubuque, IA

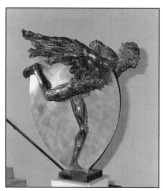

378. *The Edge*, 1975
48 inches;
Gustavus Adolphus College,
St. Peter, MN

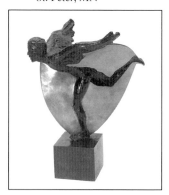

379. *The Edge Model*, 1975
10 1/2 inches

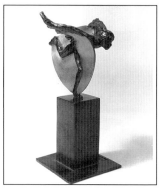

380. *The Edge Study*, 1975
6 1/2 inches

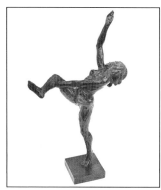

381. *Figure January 2*, 1975
23 1/4 inches

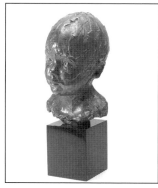

382. *Head of Timothy*, 1975
12 inches

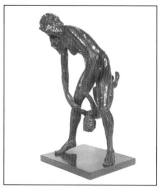

383. *Mother and Child*, 1975
28 1/2 inches

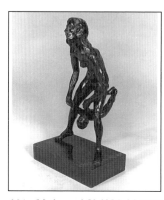

384. *Mother and Child Model*, 1975
9 1/4 inches

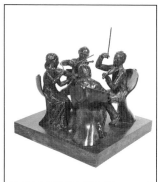

385. *Quartet*, 1975
13 1/2 inches

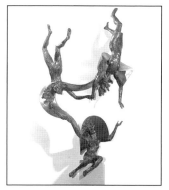

386. *Sonata*, 1975
10 feet 6 inches;
Gustavus Adolphus College,
St. Peter, MN

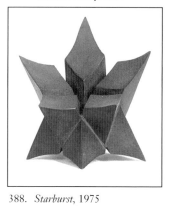

387. *Spirit of Courage*, 1975
53 inches;
Courage Center,
Golden Valley, MN

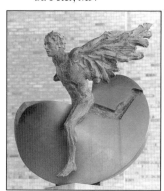

388. *Starburst*, 1975
5 1/2 inches

389. *BC AD*, 1976
6-inch cube

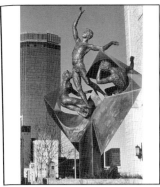

390. *Birth of Freedom*, 1976
17 feet 6 inches;
Westminster Presbyterian
Church, Minneapolis, MN

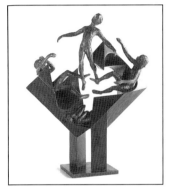

391. *Birth of Freedom Model I*, 1976
15 inches

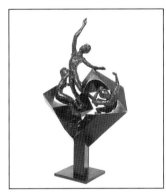

392. *Birth of Freedom Model II*, 1976
17 inches

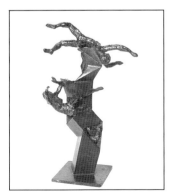

393. *Birth of Freedom Study I*, 1976
8 inches

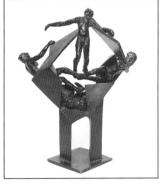

394. *Birth of Freedom Study II*, 1976
6 inches

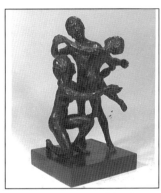

395. *Family Circle Model*, 1976
11 1/2 inches

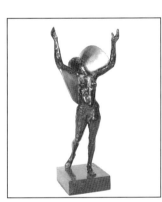

396. *Figure in Spiral*, 1976
11 inches

397. *Gustavus Adolphus
Bicentennial Royal Medal*, 1976
4 inches;
H.M. King Carl XVI Gustaf
of Sweden

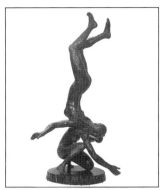

398. *Palindrome*, 1976
60 inches;
St. Mary's Greek
Orthodox Church,
Minneapolis, MN;
Gustavus Adolphus College,
St. Peter, MN

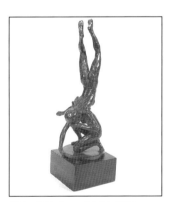

399. *Palindrome Model*, 1976
12 inches

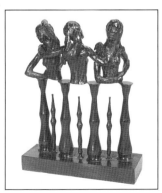

400. *Pillar to Post*, 1976
11 inches

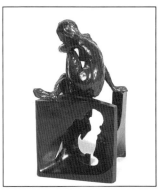

401. *Reflection I*, 1976
 9 3/4 inches

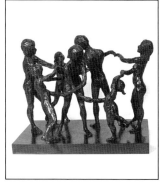

404. *Singers Model*, 1976
 11 1/2 inches

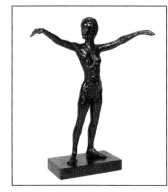

408. *Totem Figure*, 1976
 9 3/4 inches

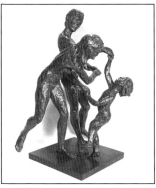

402. *Rondo*, 1976
 30 3/4 inches;
 Lutheran Church of the
 Good Shepherd,
 Minneapolis, MN

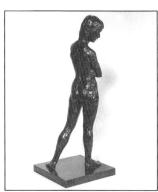

405. *Standing Figure*, 1976
 21 inches

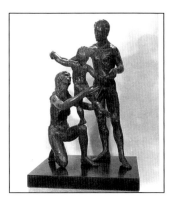

409. *Family Circle*, 1977
 58 inches

406. *The Fine Arts Award*, 1976
 3 1/2 inches;
 Gustavus Adolphus College,
 St. Peter, MN

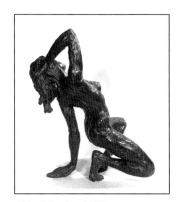

411. *Morning*, 1977
 17 1/4 inches

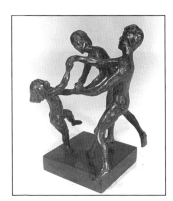

403. *Rondo Model*, 1976
 7 1/2 inches

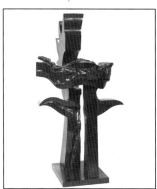

407. *Totem*, 1976
 18 1/4 inches

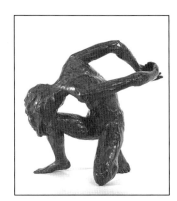

412. *Mourning*, 1977
 13 3/4 inches

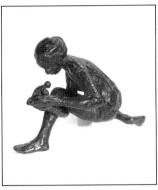

413. *On the Other Hand*, 1977
5 1/4 inches

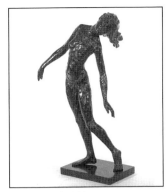

416. *Wind*, 1977
25 inches

420. *Sinistra*, 1978
27 inches

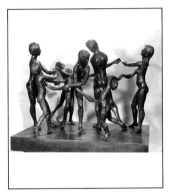

414. *Singers*, 1977
42 inches;
Lutheran Social Service
of Minnesota,
Minneapolis, MN

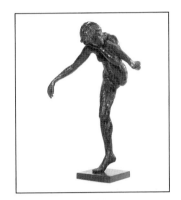

417. *Chrysalis*, 1978
23 3/4 inches

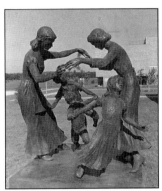

421. *The Mothers*, 1978
64 3/4 inches;
W.W. Mayo House,
Le Sueur, MN

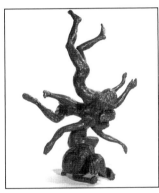

418. *Dance*, 1978
12 inches

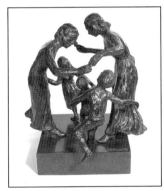

422. *The Mothers Model*, 1978
12 1/4 inches

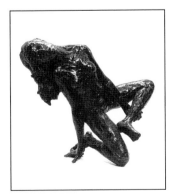

415. *Weighted on Hand and
Foot*, 1977
13 inches

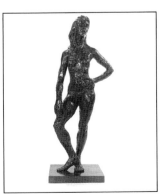

419. *Destra*, 1978
26 inches

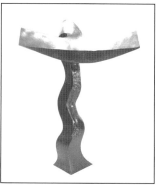

423. *The Way of the Cross*, 1978
18 1/4 inches;
St. Luke's United Methodist
Church, Oklahoma City, OK;
Roseville Lutheran Church,
Roseville, MN

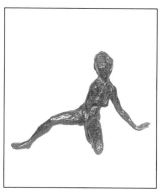

426. *Pro-Con*, 1978
8 inches

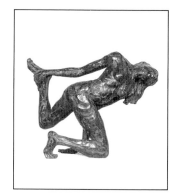

430. *Trauma*, 1978
12 1/4 inches

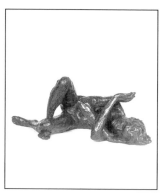

427. *Reclining Figure*, 1978
20 1/4 inches

431. *Walking Woman*, 1978
9 inches

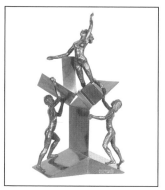

424. *Founders Model*, 1978
17 1/4 inches

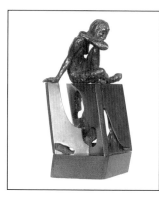

428. *Reflection II*, 1978
11 1/2 inches

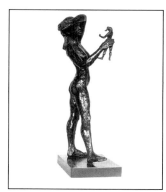

432. *Figure Holding Figure*, 1979
13 3/4 inches

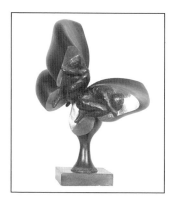

425. *Monarch Matrix*, 1978
12 inches

429. *REM*, 1978
6 1/4 x 12 1/4 inches

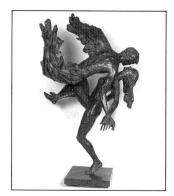

433. *Lovers with Arm and Leg
Winged*, 1979
6 feet

434. *Reflection III*, 1979
66 inches;
Owatonna Art Center,
Owatonna, MN;
La Crosse Public Library,
La Crosse, WI

437. *ad infinitum*, 1979
15 inches

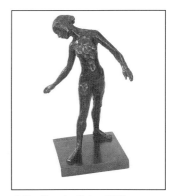

441. *Turning Point*, 1979
9 inches

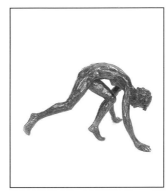

438. *Summer Assault*, 1979
5 1/4 inches

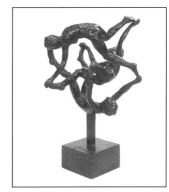

442. *Urania*, 1979
10 1/4 inches

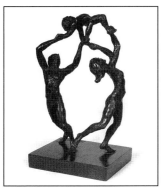

435. *Apogee Model*, 1979
9 1/4 inches

439. *Al Quie Inaugural Medal*, 1979
3 1/4 inches

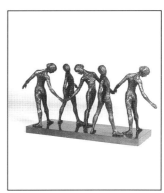

443. *Point Counterpoint*, 1979
9 1/4 inches

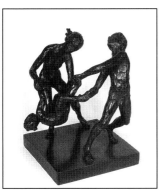

436. *Perigee*, 1979
8 inches

440. *Celebration Study–
Resurrection Element*, 1979
7 inches

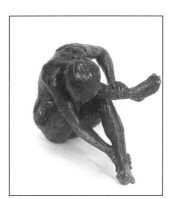

444. *Octavia*, 1979
8 3/4 inches

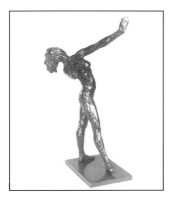

445. *Mask*, 1979
 29 inches

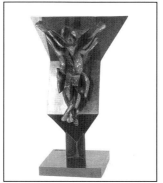

449. *Celebration Model–*
 Crucifixion Element, 1979
 13 1/2 inches

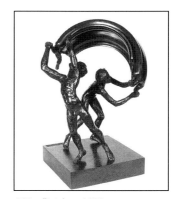

451. *Rainbow*, 1980
 8 3/4 inches

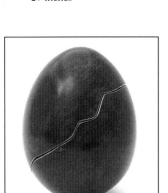

446. *Egg*, 1979
 5 inches

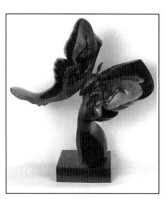

450. *Luna Moth Matrix Model*, 1979
 21 inches

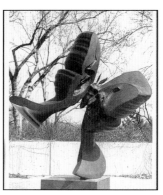

452. *Luna Moth Matrix*, 1980
 60 inches;
 Gustavus Adolphus College,
 St. Peter, MN;
 St. Paul's Lutheran Church,
 Lakeville, MN

447. *Celebration Model*, 1979
 Crucifixion Community
 Element, 13 1/2 inches

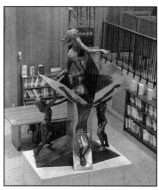

450A. *Founders*, 1979
 8 feet 6 inches;
 Concordia College,
 Moorhead, MN

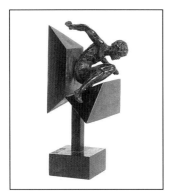

448. *Celebration Model–*
 Resurrection Element, 1979
 9 1/2 inches

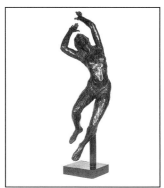

453. *Flight*, 1980
 34 inches;
 Folke Bernadotte Memorial
 Library, Gustavus Adolphus
 College, St. Peter, MN

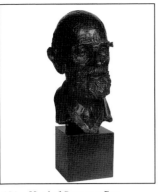

454. *Head of Composer Jan Bender*, 1980
22 inches;
Music Library,
Gustavus Adolphus College,
St. Peter, MN

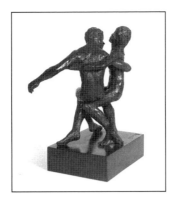

457. *Loveseat*, 1980
12 inches

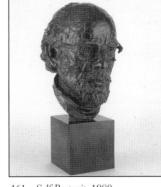

461. *Self Portrait*, 1980
18 inches

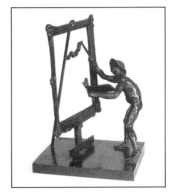

458. *Quick Sketch*, 1980
10 inches

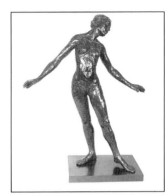

462. *Figure 1980*, 1980
25 1/2 inches

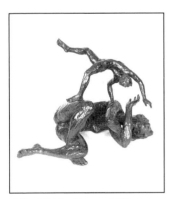

455. *Waking Dream*, 1980
14 inches

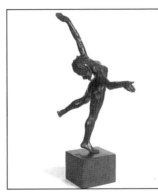

459. *Dansa*, 1980
15 inches

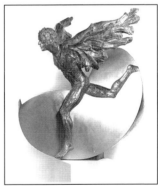

463. *Spirit of Courage Model II*, 1980
12 3/4 inches

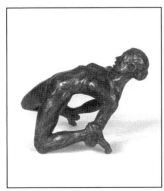

456. *In the Round Model*, 1980
6 inches

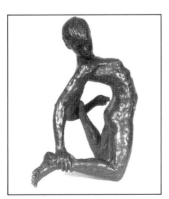

460. *In the Round*, 1980
17 inches;
Cannon Falls Library,
Cannon Falls, MN

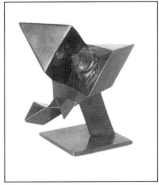

464. *Celebration Model–Creation Element*, 1980
5 inches

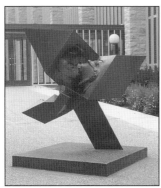

464A. *Celebration–Creation
 Element*, 1980
 5 feet;
 St. Olaf College,
 Northfield, MN

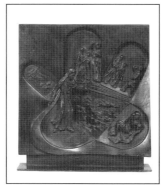

467. *Bethesda Pool Model*, 1981
 12 1/4 inches

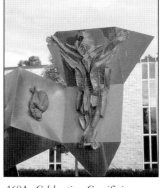

468A. *Celebration–Crucifixion
 Community Element*, 1981
 12 feet;
 St. Olaf College,
 Northfield, MN

467A. *Eckman Mall Plaque*, 1981
 14 inches;
 Gustavus Adolphus College,
 St. Peter, MN

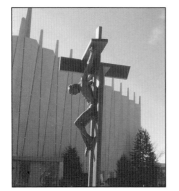

465. *Crucifixion*, 1980
 10 feet 2 inches;
 Gustavus Adolphus College,
 St. Peter, MN

467B. *President's Inaugural Medal*, 1981
 3 1/2 inches;
 Gustavus Adolphus College,
 St. Peter, MN

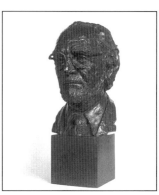

469. *Head of Cantor Paul O.
 Manz*, 1981
 22 inches;
 Mount Olive Lutheran
 Church, Minneapolis, MN

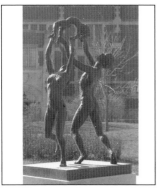

466. *Apogee*, 1980
 6 feet 2 inches;
 Gustavus Adolphus College,
 St. Peter, MN; United
 Hospital, St. Paul, MN

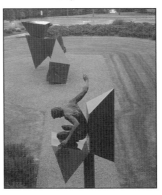

468. *Celebration–Resurrection
 Element*, 1981
 22 feet;
 St. Olaf College,
 Northfield, MN

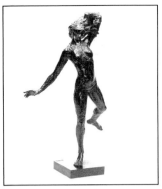

470. *South Wind I*, 1981
29 inches

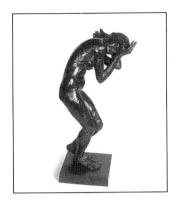

474. *North Wind*, 1981
21 inches

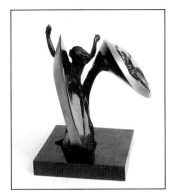

478. *Venus Nautilus I*, 1981
10 inches

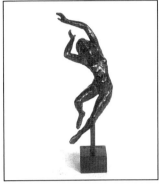

471. *Flight Model*, 1981
12 inches

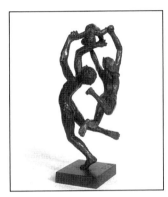

475. *Zerogee Model I*, 1981
12 inches

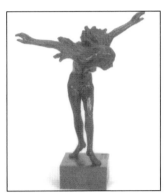

479. *West Wind Model*, 1981
11 1/2 inches

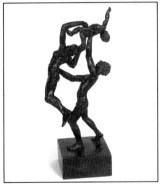

472. *Free*, 1981
10 3/4 inches;
H.E.A.R.T., Inc.,
St. Paul, MN

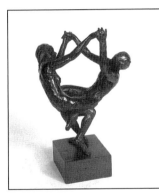

476. *Sitting One Out*, 1981
10 inches

480. *Cross Section Study*, 1981
2 1/2 inches

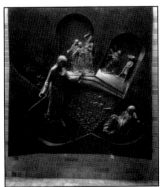

473. *Bethesda Pool*, 1981
66 inches;
Bethesda Lutheran Home,
Watertown, WI

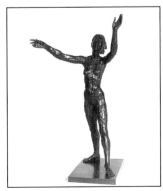

477. *Venus Figure I*, 1981
9 1/2 inches

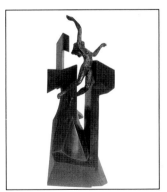

480A. *Cross Section Model*, 1982
15 1/2 inches

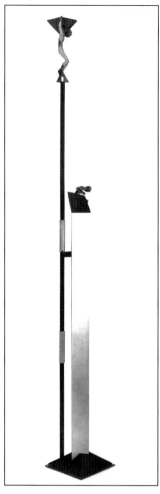

481. *Crucifixion-Resurrection*, 1982
processional cross,
7 feet 1 1/2 inches

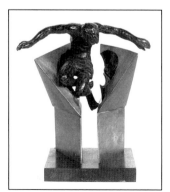

482. *Resurrection Model*, 1982
8 1/2 inches

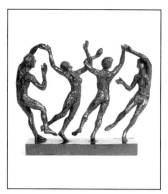

483. *Dance Profile*, 1982
8 1/4 inches

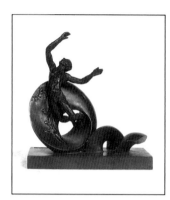

484. *Disc*, 1982
5 3/4 inches

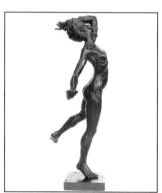

485. *South Wind II*, 1982
42 inches;
Gustavus Adolphus College,
St Peter, MN

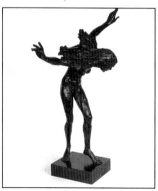

486. *West Wind*, 1982
31 inches

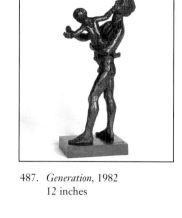

487. *Generation*, 1982
12 inches

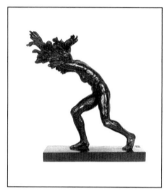

488. *East Wind*, 1982
11 1/4 inches

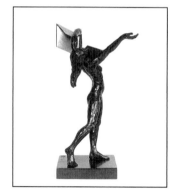

489. *Aurora*, 1982
12 inches

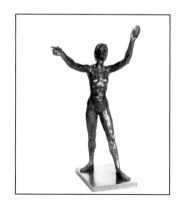

490. *Venus Figure II*, 1982
33 inches

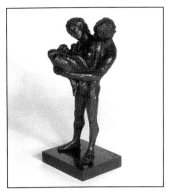

491. *Cradle Model*, 1982
10 inches

491A. *First Lutheran Medallion*, 1982
9 1/4 inches

491B. *First Lutheran Medallion*, 1982
2 inches

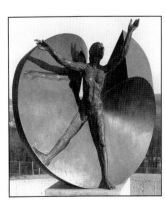

492. *Venus Nautilus II*, 1983
34 inches;
St. Francis Regional Medical
Center, Shakopee, MN;
Gustavus Adolphus College,
St Peter, MN

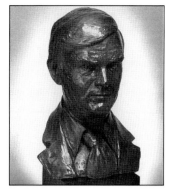

493. *Portrait of Nicholas D.
Coleman*, 1983
23 inches;
Minnesota State Capitol,
St. Paul, MN

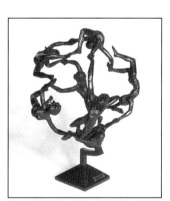

494. *Constellation Earth Model*, 1983
14 1/4 inches

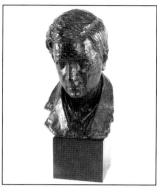

495. *Portrait of Srinivasa
Ramanujan*, 1983
22 1/2 inches;
India, England, and the
United States

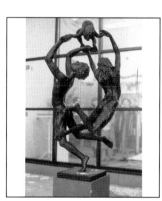

496. *Zerogee*, 1983
65 1/2 inches;
The College of St.
Catherine, St. Paul, MN;
Missouri Botanical Garden,
St. Louis, MO;
Norskedalen Arboretum,
Coon Valley, WI

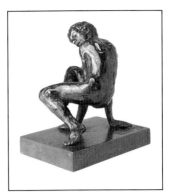

497. *Taciturn*, 1983
5 1/2 inches

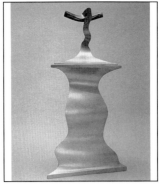

501. *Baptismal Font*, 1983
57 inches;
St. Paul's Lutheran Church,
Annapolis, MD

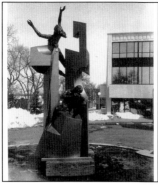

503A. *Cross Section*, 1983
10 feet;
Sioux Falls College,
Sioux Falls, SD;
Hong Kong International
School, Repulse Bay,
Hong Kong

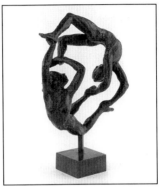

498. *Orbit Model*, 1983
14 inches

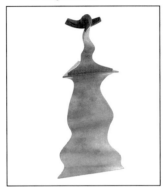

502. *Baptismal Font Model*, 1983
12 inches

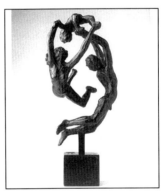

499. *Zerogee Model II*, 1983
8 1/2 inches

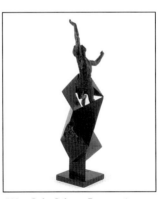

503. *Cube Column Resurrection
Model*, 1983
13 1/2 inches

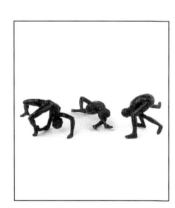

504. *Floor Exercises*, 1984
3 figures, 4 1/2 inches

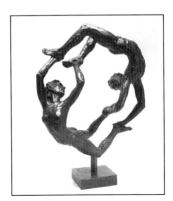

500. *Orbit* , 1983
31 1/2 inches

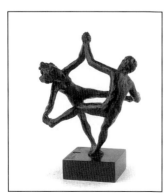

505. *Adult Lessons*, 1984
8 inches

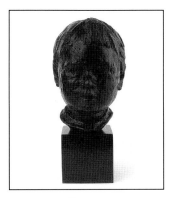

506. *Head of Joshua*, 1984
13 1/2 inches

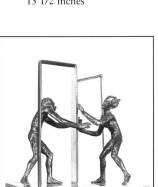

507. *Adolescence Model*, 1984
9 1/2 inches

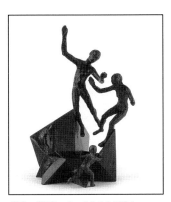

508. *Wellspring Model*, 1984
12 inches

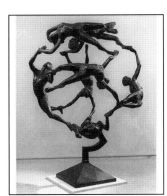

509. *Constellation Earth*, 1984
8 feet;
University of St. Thomas,
St. Paul, MN;
Methodist Hospital,
Rochester, MN

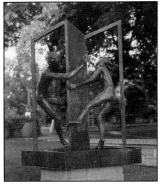

510. *Adolescence*, 1984
6 feet;
The Constance Bultman
Wilson Center,
Faribault, MN

511. *Half Tryst*, 1984
12 inches

512. *Voila*, 1984
12 1/2 inches

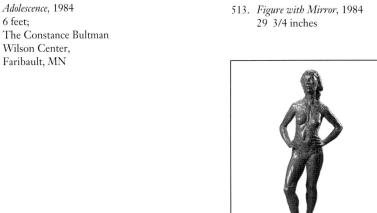

513. *Figure with Mirror*, 1984
29 3/4 inches

514. *Figure 1984*, 1984
29 3/4 inches

515. *Portrait/Bust of Bernt Julius
Muus*, 1984
25 inches;
St. Olaf College,
Northfield, MN

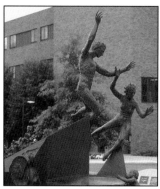

516. *Wellspring,* 1985
14 feet;
Abbott Northwestern Hospital,
Minneapolis, MN

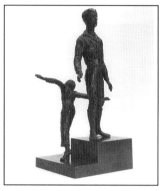

517. *Charles A. Lindbergh-The Boy
and The Man Model I,* 1985
13 inches

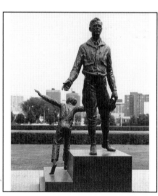

518. *Charles A. Lindbergh-The Boy
and The Man,* 1985
9 feet 8 inches;
Minnesota State Capitol,
St. Paul, MN;
Le Bourget Field,
Paris, France;
Lindbergh Field,
San Diego, CA

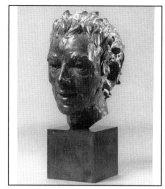

519. *Male Head,* 1985
22 inches

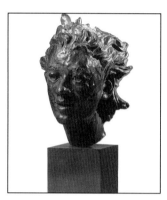

520. *Female Head,* 1985
22 1/2 inches

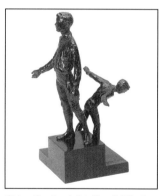

521. *Charles A. Lindbergh-The Boy
and The Man Model II,* 1985
13 inches

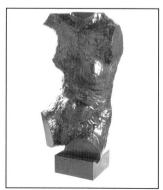

522. *Torso,* 1985
34 1/2 inches

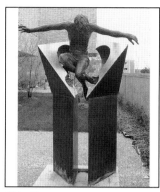

523. *Resurrection,* 1985
7 feet 3 1/2 inches;
First Lutheran Church,
Pittsburgh, PA

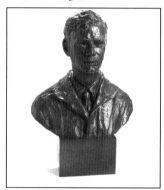

524. *Charles A. Lindbergh
Portrait/Head,* 1985
32 3/4 inches;
San Diego Aero-Space
Museum, San Diego, CA

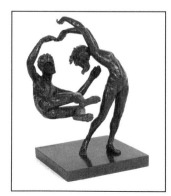

525. *Half Tryst and the Other
Half,* 1985
12 inches

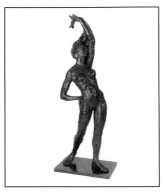

526. *Dawn*, 1985
41 1/4 inches

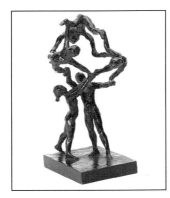

530. *Familia Study*, 1985
6 1/4 inches

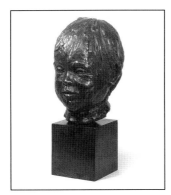

531B. *Max Musicant*, 1985
25 inches

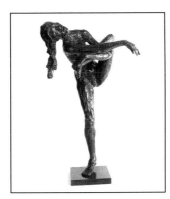

527. *Suspended Animation*, 1985
13 inches

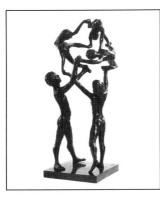

530A. *Familia Model*, 1985
19 inches

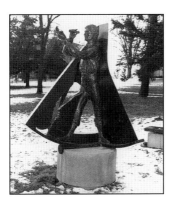

531C. *Nicollet*, 1986
48 inches;
Gustavus Adolphus College,
St. Peter, MN

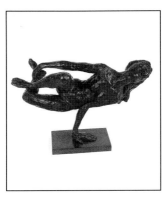

528. *Earth Hostage*, 1985
22 1/2 inches

529. *Resurrection*, 1985
6 feet 1 1/2 inches;
Central Lutheran Church,
Minneapolis, MN

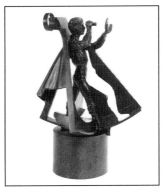

531. *Nicollet Model*, 1986
14 inches

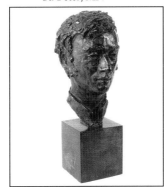

531D. *Nicollet Head*, 1986
16 1/2 inches

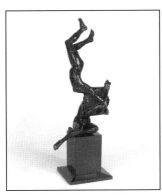

531A. *Masks of the Muses Mirror
Image*, 1986
14 3/4 inches

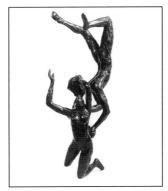

532. *Impromptu*, 1986
12 1/2 inches

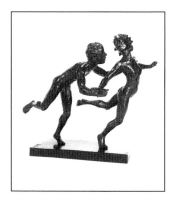

533. *The Chase*, 1986
14 inches

534. *Crucifixion Altar Element*, 1986
24 inches

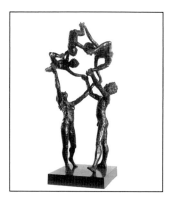

535. *Familia II*, 1986
48 inches

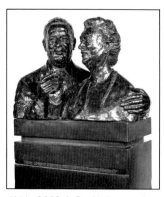

535A. *McNeely Double Portrait I*,
1986
72 inches; University of
St. Thomas, St. Paul, MN

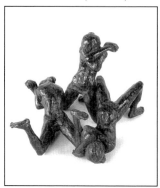

536. *For They Shall Be
Comforted*, 1986
6 3/4 inches

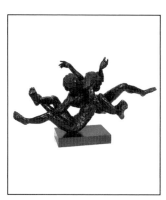

537. *Horizontal Lovers III*, 1986
20 1/2 x 39 inches

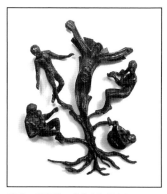

538. *Life Tree Model*, 1986
17 inches

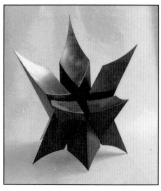

539. *Starburst*, 1986
56 inches, bronze and
stainless steel

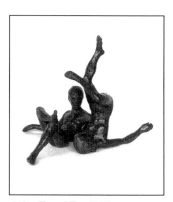

540. *To and Fro*, 1986
7 inches

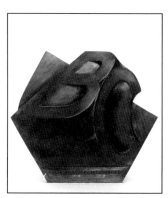

540A. *Medallion of the President*, 1986
10 inches;
Gustavus Adolphus College,
St. Peter, MN

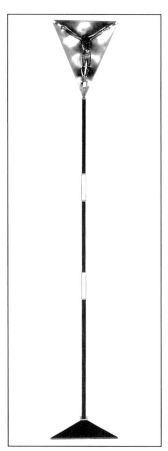

534A. *Processional Crucifixion*, 1986
7 feet 9 inches

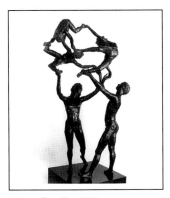

541. *Familia*, 1986
10 feet;
Lifetouch National School Studios,
Minneapolis, MN

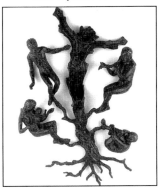

542. *Life Tree*, 1986
32 inches;
Salem Lutheran Church,
Bridgeport, CT;
St. Paul Seminary, St. Paul,
MN; Lutheran Church of
the Good Shepherd,
Minneapolis, MN

543. *McNeely Double
Portrait II*, 1987
17 inches

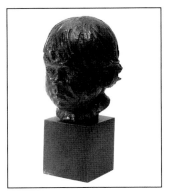

543A. *Head of Marc*, 1987
14 inches

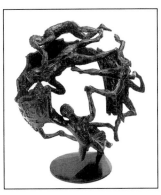

544. *Anthrosphere Model*, 1987
17 1/2 inches

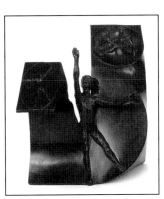

545. *The Time Being Model II*, 1987
12 1/4 inches

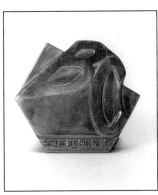

545A. *Medallion of the President*, 1987
2 1/2 inches;
Gustavus Adolphus College,
St. Peter, MN

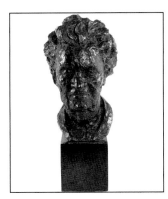

546. *Head of My Mother*, 1986
21 inches

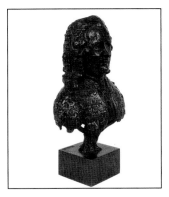

547. *Linnaeus Model*, 1988
15 3/4 inches

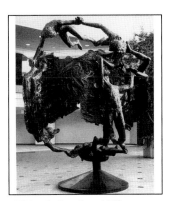

547A. *Anthrosphere*, 1988
14 feet;
World Trade Center,
St. Paul, MN

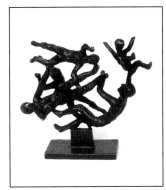

548. *Swimmers Study*, 1988
4 1/4 inches

121

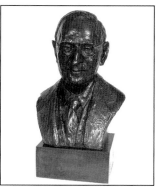

549. *Portrait/Head of Frank
 Buchman*, 1988
 24 inches;
 Muhlenberg College,
 Allentown, PA;
 Switzerland

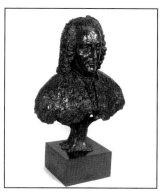

551. *Linnaeus (Head of Carl von
 Linné)*, 1988
 35 inches;
 Gustavus Adolphus College,
 St. Peter, MN; The Linnaeus
 Garden, Uppsala, Sweden;
 Missouri Botanical Garden,
 St. Louis, MO

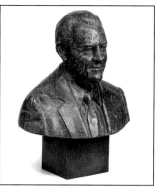

554. *Portrait /Head of
 Thomas E. James*, 1988
 27 inches

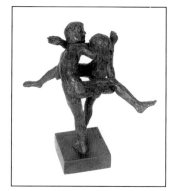

555. *Toe to Toe*, 1988
 10 3/4 inches

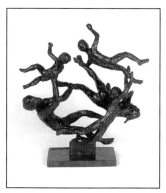

550. *Swimmers Model*, 1988
 9 inches

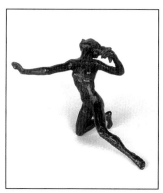

552. *Iris*, 1988
 8 inches

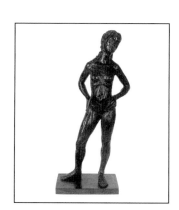

555A. *Figure Study*, 1988
 28 1/2 inches

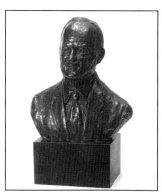

553. *Portrait /Head of Hubert H.
 Humphrey Model*, 1988
 13 1/2 inches

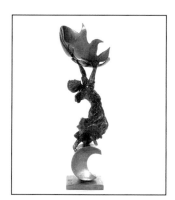

556. *Saint Francis Model*, 1988
 17 inches

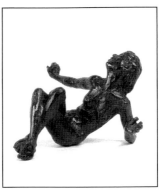

557. *Looking Back*, 1989
4 1/2 x 8 1/2 inches

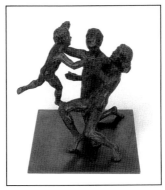

558. *Pride and Joy*, 1989
11 1/4 inches

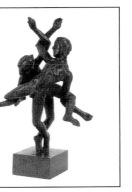

559. *Thunder and Lightning Model*, 1989
10 1/2 inches

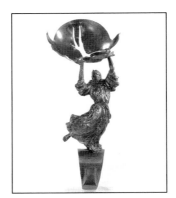

560. *Saint Francis*, 1989
9 feet;
Viterbo College,
La Crosse, WI

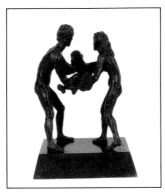

561. *Care*, 1989
9 inches

562. *Alpha and Omega Sundial Model*, 1989
9 1/2 inches

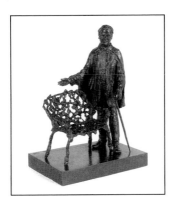

563. *Henry Shaw Model*, 1989
11 inches

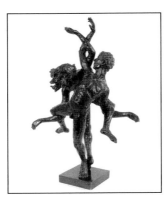

564. *Thunder and Lightning*, 1989
33 inches

565. *Climatron Relief*, 1989
14 inches;
Missouri Botanical Garden,
St. Louis, MO

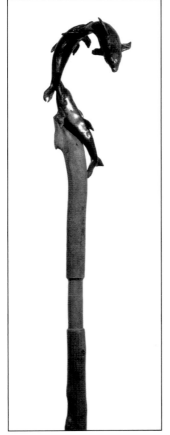

566. *Dolphin Crosier*, 1989
6 feet 5 inches,
bronze and driftwood;
Christ Chapel,
Gustavus Adolphus College,
St. Peter, MN

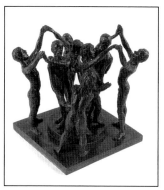

567. *Double Chorus*, 1990
 12 inches

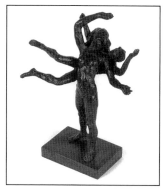

570. *Corona*, 1990
 11 inches

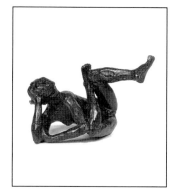

574. *B Muse*, 1990
 7 inches

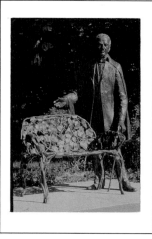

568. *Henry Shaw*, 1990
 6 feet 3 inches;
 Missouri Botanical Garden,
 St. Louis, MO

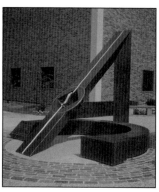

571. *Alpha and Omega Sundial*, 1989
 9 feet 6 inches;
 Grinnell College, Grinnell, IA

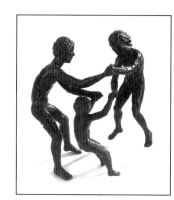

575. *Teeter Trio*, 1990
 10 inches

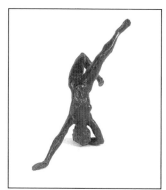

572. *A Muse*, 1990
 10 1/2 inches

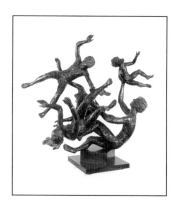

576. *Swimmers*, 1990
 54 inches

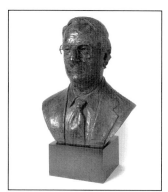

569. *Portrait/Head of Edward A.
 Burdick*, 1990
 22 1/2 inches;
 Minnesota State Capitol,
 St. Paul, MN

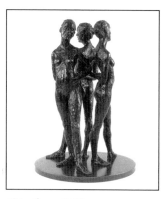

573. *Grace*, 1990
 27 inches

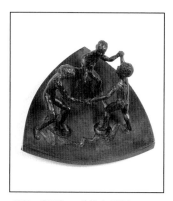

577. *Children of God*, 1990
 9 x 10 inches

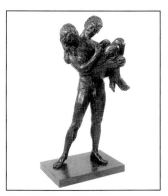

578. *Cradle*, 1991
48 inches

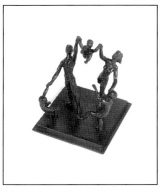

579. *Lofting Study*, 1991
6 inches

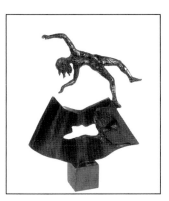

580. *Arch Angle*, 1991
20 inches

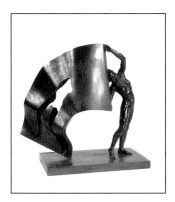

581. *Isadora*, 1991
14 inches

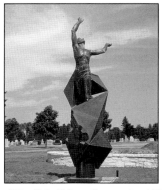

582. *Cube Column Resurrection*, 1991
14 feet 6 inches;
Roselawn Cemetery,
Roseville, MN

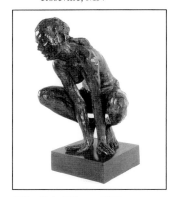

583. *Poised Figure*, 1991
15 1/2 inches

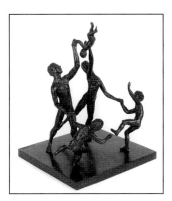

584. *Lofting Model*, 1991
13 3/4 inches

INDEX

Listings in italics represent sculpture photo references.

A Muse, 58, *58, 124*
Abandoned Figure, 99
Abbott Northwestern Hospital (Minneapolis, MN), 41
Abstract, 71
ad infinitum, 19, 20, 21, *109*
Adolescence, 8, 9-10, *117*
Adolescence Model, 117
Adolescent 1951, 69
Adolescent 1955, 75
Adolescent 1957, 76
Adolescent and Child, 96
Adore Knocker, 97
Adult Lessons, 9, *9, 116*
Aeneid, Vergil, 23
Aggression, 71
Al Quie Inaugural Medal, 109
Albee, Edward, 43
Allegorical Figure, 82
Alpha and Omega Sundial, 36, *36, 124*
Alpha and Omega Sundial Model, 123
Ambivalence I, 12, *78*
Ambivalence II, 12, *80*
Ambivalence III, 12, *12, 82*
Ambivalence IV, 12, *93*
Ambivalence IV Head, 96
Anthrosphere, 34-35, *35, 121*
Anthrosphere Model, 121
Apathy, 80
Apogee, 18, 19, 22, *112*
Apogee Model, 109
Arch Angle, 125
Ascendance, 99
Ascendance Model, 99
Ascetic, 69
Askey, Richard, 23
At One Ment 1963, 87
At One Ment 1974, 102
Aurora, 114

B Muse, 58, *124*
B to A+, 99
Baby, 69
Bacio I, 15, *87*
Bacio II, 87
Balanced Figure 1959, 80
Balanced Figure 1970, 98
Baptismal Font, 53, 54, *116*
Baptismal Font Model, 116
Baptism/Lord's Supper Door, 87
Bather 1955, 12, *75*
Bather 1958, 78
BC AD 1973, 101
BC AD 1976, 104
BC AD Model, 99
Bell, 102
Bernt Julius Muus, 23
Bethesda Angel, 12, *12,* 54, *95*
Bethesda Angel Model I, 95
Bethesda Angel Model II, 96
Bethesda Lutheran Home (Watertown, WI), 54
Bethesda Pool, 54, *54, 113*
Bethesda Pool Model, 112

Birth, 83
Birth: in Granlund's work, 13-17, 29-50, 55-56
Birth of Freedom, 41-42, *41, 105*
Birth of Freedom Model I, 105
Birth of Freedom Model II, 105
Birth of Freedom Study I, 105
Birth of Freedom Study II, 105
Birth of Myth, 13, *13, 87*
Bisymmetric Figure I, 83
Bisymmetric Figure II, 83
Bloom, Harold, 26
Bonnie, 83
Boy with Foot, 76
Boys, Washington Model I, 93
Bridge, 102

Care, 123
Cassandra, 91
Celebration, 27-31. See also Community; Creation; Crucifixion; Resurrection
Celebration—Creation Element, 112
Celebration—Crucifixion Community Element, 28, 29, 30, *112*
Celebration—Resurrection Element, 112
Celebration Model, 110
Celebration Model—Creation Element, 111
Celebration Model—Crucifixion Element, 110
Celebration Model—Resurrection Element, 27, *110*
Celebration Study—Resurrection Element, 109
Chancel Crucifixion, 102
Charles A. Lindbergh Portrait/Head, 25, *118*
Charles A. Lindbergh—The Boy and The Man, 25-26, *25, 118*
Charles A. Lindbergh—The Boy and The Man Model I, 118
Charles A. Lindbergh—The Boy and The Man Model II, 118
Chase, The, 120
Children, 87
Children Model, 87
Children of God, 37, *124*
Christ Chapel (Gustavus Adolphus College), 26
Christ Door, 84
Christ, Jesus: in Granlund's work, 26, 28, 29, 46, 52-56
Christ, Peter and Paul, 88
Christenson, Kathryn, 49
Chrysalis, 107
Climatron Relief, 123
Colts, 92
Community, 29-31, *29*
Compact Figure, 80
Concordia College, (Moorhead, MN), 42-43
Constellation Earth, 31, *32,* 33-35, *117*
Constellation Earth Model, 115
Continuum, 21, *21, 103*
Continuum Model, 101

Corona, 36, 37, *124*
Courage Center (Golden Valley, MN), 56
Crack the Whip, 102
Cradle, 125
Cradle Model, 115
Creation, 27-31
Credo Doors, left, *94*
Credo Doors, right, *94*
Cross 1973, 101
Cross 1974, 102
Cross Section, 53, *53-54,116*
Cross Section Model, 113
Cross Section Study, 113
Crucifixion 1951, 70
Crucifixion 1953, 72
Crucifixion 1957, 77
Crucifixion 1964, 89
Crucifixion 1967, 52, *52, 94*
Crucifixion 1969, (processional cross), *97*
Crucifixion 1970, 52, *52, 98*
Crucifixion 1980, 29-31, *112*
Crucifixion Altar Element, 120
Crucifixion Model 1962, 85
Crucifixion Model 1964, 89
Crucifixion Model 1967, 94
Crucifixion Relief, 77
Crucifixion Relief Study, 77
Crucifixion-Resurrection, 54, *54, 114*
Cube Column Resurrection, 54-56, *55,* 59, *125*
Cube Column Resurrection Model, 116
Cube Star, 99
Cube Star Model, 98

Damascus Illumination, 94
Damascus Illumination Model, 91
Dance, 14, *14, 107*
Dance: in Granlund's work, 45-46, 49-52
Dance Profile, 114
Dancing Francis, (Saint Francis), 43-46
Dansa, 111
Daphne, 91
Dawn, 119
Death: in Granlund's work, 15, 17, 21, 37, 41, 49, 55-56
Defense Mechanism, 75
Defiant, 71
Deposition I, 79
Deposition II, 79
Deposition III, 79
Deposition Study, 77
Destra, 107
Diane, 89
Disc, 114
Dissolution, 75
Dolphin Crosier, 123
Double Chorus, 124
Double Phoenix, 83
Double S, 100
Double S Model, 99
Draped Figure I, 75
Draped Figure II, 75
Dubuque, IA, 21

Earth and Sky, 102
Earth Hostage, 57, 58, *119*
East Wind, 37, *37, 114*
Eckman Mall Plaque, 112
Edge, The, 104
Edge Model, The, 104
Edge Study, The, 104
Egg, 10, *10, 110*
Embrace, 88
Emerging Figure, 91
Eulogy, 91
Europa and the Bull I, 85
Europa and the Bull II, 85
Europa and the Bull III, 85
Eve, 77

Falling Figure, 79
Familia, 121
Familia II, 40, *40, 120*
Familia Model, 119
Familia Study, 119
Family 1951, 70
Family 1952, 71
Family 1954, 73
Family 1974, 103
Family Circle, 22, *106*
Family Circle Model, 105
Family: in Granlund's work, 9-10, 18-24, 40-41, 48-49
Family Model, 103
Father and Son, 22, *22, 69*
Father and Son I, 96
Father and Son I Model, 88
Father and Son II, 96
Father Damien, 94
Father Flanagan Figure, 94
Father Flanagan Portrait 1966, 93
Father Flanagan Portrait 1967, 95
Father Flanagan Washington Model I, 96
Father Flanagan Washington Model II, 96
Father Flanagan Washington Model III, 98
Female Head, 118
Fetus, from *Christ Door, 84*
Fetus Relief, 73
Figure, 71
Figure 1980, 111
Figure 1984, 117
Figure Against a Wall, 91
Figure Balanced on One Foot, 83
Figure Cubed and Sphered, 100
Figure Holding Feet, 83
Figure Holding Feet Winged, 83
Figure Holding Figure, 108
Figure Holding Leg 1971, 99
Figure Holding Leg 1974, 103
Figure in Planes, 96
Figure in Rotation, 89
Figure in Spiral, 105
Figure in the Garden, 75
Figure January 2, 104
Figure March '60, 83
Figure October 5, 103
Figure on Elbow and Heel, 85

126